Walter De Maria
The Vertical Earth Kilometer
Kassel, Germany

Max Neuhaus
Times Square

Dia Chelsea

Joseph Beuys
7000 Eichen (7000 Oaks)

Walter De Maria
The New York Earth Room

Walter De Maria
The Broken Kilometer

New York City

an introduction to Dia's
locations and sites

edited by
Kamilah N. Foreman
Matilde Guidelli-Guidi
Sophia Larigakis

Dia Art Foundation

Contents

To James Schaeufele for his unwavering dedication to Dia

Preface

Dia Art Foundation was established in 1974 to partner with artists and help realize their visions, which have manifested in ambitious projects sited in the landscape and the urban fabric. These site-specific works posited new relationships with viewers and their surroundings and spurred a new model of institutional stewardship. Following the lead of artists who challenged the traditional studio, gallery, and museum system at a time of social change in the late 1960s, Dia was conceived as a counterinstitution. It remains decentralized and multilocational, supporting the development of new artist projects while managing long-term sited works and facilitating their public visitation. The foundation's commitment to long-term presentations encourages our visitors to engage with artworks again and again.

This book is your guide to Dia today. It focuses on our three locations, at which we present exhibitions and commissions, and eight sites of permanent artworks by individual artists, some of which have been in our care since the 1970s. With few exceptions, we have collaborated with artists to realize these locations and sites, and the details of those partnerships unfold within these pages. The sections devoted to the sites include reprints of landmark texts by the artists reflecting on their work. This exploration of our current locations and sites is supplemented by a time line of Dia's long-term, sited projects, past and present.

Just as this volume reflects Dia at this juncture, so too does it evince a particular moment in history. Widespread social-justice activism during the summer of 2020 as this book was being produced has prompted meaningful dialogue among the staff about how Dia is not neutral. As this volume illuminates what makes us unique in the art world and has given countless visitors memorable experiences, we would be remiss if we did not acknowledge how some of our lauded qualities, such as the reappropriation of so-called empty or aban-doned cityscapes and landscapes, have complicated sociopolitical histories that continue to affect the world around us.

The same critical impulse that drove Dia's cofounders to establish an alternative model to traditional art institutions makes its history inextricable from the politics of place. The questions of site-specificity and site-responsiveness, wherein artworks are made in relation to a certain space, are loaded. Just as Dia is not neutral, there is no such thing as a neutral site, a fact many artists in our collection have contended with. As an institution, we must reckon with our role in processes of gentrification, displacement, and dispossession. Our acquisition of several buildings in downtown New York since the 1970s allowed us to advance our mission amid the widespread deindustrialization of the city. The creation of Dia Beacon in the Hudson Valley at the turn of the millennium also correlates with the rise in real estate prices upstate. Further, our Land artworks in the western United States share in the foundational dynamics of settler colonialism and cultural appropriation. Throughout our history, we have presented programs that participate in public debates about democracy, race, gender, sexuality, activism, and more, but this current moment marks a shift in our understanding about the need for a long-term, sustained commitment to denaturalizing and dismantling a canon that we have helped establish, as well as working to eliminate inequity within the structure of the institution itself. Vital for the organization, this reckoning and the new narratives that will ensue will foster a more accountable and inclusive community around the art we steward, display, and commission. Dia's singularity and flexibility as an institution opens up the potential for the kinds of seismic shifts—both programmatic and internal—that a more just future demands.

Kamilah N. Foreman, Director of Publications
Matilde Guidelli-Guidi, Associate Curator
Sophia Larigakis, Editorial and Publications Assistant

Acknowledgments

This volume offers an opportunity to thank the innumerable people who have enlivened the radical proposition that is Dia. We are extremely grateful to the artists who have entrusted us to engage with and realize their ideas and to be stewards of their work. In conceiving the idea of a multisite institution dedicated to single-artist projects, cofounders Fariha Friedrich, Heiner Friedrich, and Helen Winkler Fosdick established a new kind of legacy. Their concept could not have been sustained for decades without an exceptional team, on the frontlines and behind the scenes. Acknowledgments for a volume of this type always fall short, as hundreds of people have shaped the institution over the years. Among the many individuals, whether current or former staff, who have maintained our locations and sites, designed our programs, or engaged our visitors for around a decade are Kathleen Anderson, Rendell Archibald, Chad Bowen, Carolyn Kay Carson, Barbara Clausen, Mandana Dalaei-Khojasteh, Karey David, Stephen Dewhurst, Kurt Diebboll, Patti Dilworth, William Dilworth, Joan Duddy, Steven Evans, Laura Fields, Kady Fonseca, Bettina Funcke, Heidie Giannotti, Brian Gilmartin, Curtis Harvey, Patrick Heilman, Karen Kelly, Christine Lidrbach, Claire Lofrese, Michelle Marozik, John Patrick Murphy, Kirsten Nash, Daniel Oates-Kuhn, Laura Raicovich, Elizabeth Peck, Kristin Poor, Armelle Pradalier, James Schaeufele, Caroline Schneider, Barbara Schroeder, Kathleen Shields, John Sprague, Sara Tucker, Stephan Urbaschek, Mark Walker, Susan Walker, Robert Weathers, Dan Wolfe, Fernando Zelaya, and Hanneke Zuckerman.

It takes a particular type of patron of the arts to serve on the board of trustees of an institution like Dia. For decades, our engaged board has demonstrated true leadership through thoughtful governance while fostering profound independence for our artists and support of staff to realize those creative ambitions. We owe a sincere debt of gratitude to board chairs Friedrich, De Menil, Winkler Fosdick, Ashton Hawkins, Charles Wright, Leonard Riggio, and Nathalie de Gunzburg for their wise counsel and heartfelt care for the institution. My predecessors as director, Wright, Michael Govan, Jeffrey Weiss, and Philippe Vergne, stewarded Dia through numerous challenges

and opportunities and set the institution up for enduring success. In recent years, our collection has expanded along gendered and geographic lines, including Nancy Holt's *Sun Tunnels* (1973–76); access has increased through our offer of free admission to all of our New York City spaces; and rising support from members, donors, and partnering institutions have facilitated even more programs, in-person or digital, for our visitors.

Our curatorial program has been shaped over the years with great foresight by remarkable curators such as Gary Garrels, Lynne Cooke, Yasmil Raymond, James Meyer, and Courtney J. Martin. Led by Kelly Kivland and Alexis Lowry, and advised by Donna De Salvo, the department today, consisting of Matilde Guidelli-Guidi, Theodora Lang, and Megan Holly Witko, continues this tradition of caring for our expanded collection and presenting innovative programs of contemporary art and culture at large. Some essays within this volume have been adapted from earlier institutional writing, and we are indebted to staff members who have thought about our history for years as well as to Guidelli-Guidi, Kivland, and Lowry as well as Joseph P. Henry, Dia's 2018–19 Andrew W. Mellon Curatorial Fellow, for authoring new texts for this volume. Witko and interns Ashleigh Deosaran, Mike DiPietrantonio, Samara Johnson, Geneviève Marcil, Zuna Masa, and Chris Murtha aided with essential research.

Janeen Schiff mined the archives for little-known gems, and we are proud to publish for the first time new archival imagery and documentation. Thanks also go to our development team for the work they do in securing support for our locations and sites.

At Dia, education is as vital as curation in providing access to art. Whether conceptual or hands-on, these programs for all ages are designed for long-term, participant-driven, open-ended inquiry—in and beyond our galleries and sites. Artist educators from all over New York City and the Hudson Valley devise and facilitate programs that put pedagogical and critical theory into practice. In addition, the gallery attendants, our primary experts in visitor experience, aid viewers as they navigate our physical spaces by providing a wealth of access points to the art on display. Education initiatives began in 1993 in New York, where they existed part and parcel with community outreach and public programs such as lectures and talks. Extending to Beacon in 2001, two years prior to the opening of the

exhibition space upstate, opportunities for learning expanded in size and scope over the decades in part due to the significant relationships developed with local public schools and community organizations. We sincerely thank our founding educators in both New York and Beacon: Sarah Bachlier, Jose Blondet, Max Hernandez-Calvo, Christine Hou, April Lee, Brighde Mullins, and Dina Weiss. Under the direction of Meagan Mattingly, today's Learning and Engagement Department, composed of Valerie Chang, Ashanti Chaplin, Devin Malone, Alexandra Vargo, and the team of educators, continues to innovate by committing to the powerful notion that the participants are cultural producers in their own right. In addition, members of Learning and Engagement have been leaders in making the institution more accessible and accountable. We are deeply grateful to Chang, Malone, Mattingly, and Vargo for their insightful critiques of the preface to this volume.

Our publications program has maintained a similarly innovative, multifaceted engagement with the public. Over the years Dia has produced few standard catalogues, focusing instead on monographs, artist books, symposium volumes, and poetry chapbooks, all while experimenting with form through multimedia publications. Our gratitude goes out in particular to Funcke, Kelly, and Schroeder, who from the 1990s to early 2010s built the Publications Department into what it is today.

This publication is made possible by significant support from Susan and Larry Marx, who have generously supported many Dia projects. A collaboration between the Curatorial and Publications departments, the volume was edited by Kamilah N. Foreman and Sophia Larigakis and designed by Laura Fields. Mollie Bernstein secured hi-res images and copyright permissions as well as commissioned new photography from Don Stahl. Independent cartographer Anandaroop Roy created the elegant map in the endpapers, and Damion Searles skillfully translated the excerpted interview with Joseph Beuys.

Jessica Morgan, Natalie de Gunzburg director

Dia cofounders Fariha Friedrich, Heiner Friedrich, and
Helen Winkler Fosdick at *The Lightning Field* site,
western New Mexico, ca. 1976; Heiner Friedrich, left,
top and middle; Winkler Fosdick and Fariha Friedrich,
bottom, left and right

Introduction *Jessica Morgan*

Dia Art Foundation is at heart a concept-based institution, a fact supported by its name, from an ancient Greek word meaning "through."[1] This unusual designation, linking an art foundation with the idea of a passage or conduit, highlights time as a central element of the mission. Temporality and duration are understood at Dia in many ways: the time given to an artist to conceive and create; the longevity of a project; an artwork's relationship to the time of day or season; and the ability for viewers to revisit a work over months, years, or perhaps even a lifetime. Never associated with one site or location, nor even solely with New York City where it was founded, Dia focuses instead on individual artists' visions and the realization of works wherever they may be constituted. As outlined in its founding mission statement of 1974, Dia was established for the purpose of "commissioning and presenting major works of art to the public," and it was hoped that "such active and ongoing endeavors to achieve the construction and public presentation of each single work will result in lasting qualities which people will want to experience in single and repeated visits."[2] Dia's three cofounders—Fariha Friedrich, Heiner Friedrich, and Helen Winkler Fosdick (p. 10)—established an ethos and directive that remain at the center of the institution's activities, and these qualities of time and the open encounter with a work continue to differentiate Dia in the now-crowded field of contemporary art.[3]

A New Kind of Support

Visual art was only one focus of Dia's founding, and the restated certificate of incorporation states that the foundation "may engage in, promote, encourage and assist in the support and development of the visual arts, performing arts, literary arts and scholarship, and of the sciences with primary emphasis on those projects which cannot obtain sponsorship or support from other private sources because of their nature and scale."[4] Though Dia was not alone in this spirit of aesthetic expansiveness, it undertook this work in a unique manner and remains true to this dedication through a multidisciplinary program for visual art, critical writing, philosophy, poetry, dance, and sound.

Dia was founded without a specific building to represent or house its activities.[5] In fact, this lack of a concrete space or permanent identifier was central to prioritizing the artists' visions. The ambition was not to create containers for art but rather to follow the artists' mandates wherever they may lead. The inaugural statement also notes that the "commissions are requests to artists to execute works conceived by them and to determine the nature of the environment for these works and the manner in which the works will be visited."[6] In a radical act of empowerment, Dia allowed for artistic license to determine the location and nature of the encounter. This open-ended approach and the unconditional support of the de Menil family ultimately created the conditions for the realization of some major Land artworks in the 1970s, and with this unrestricted attitude Dia helped to envision or bring into being such works as Walter De Maria's *The Lightning Field* (1977, pp. 50, 99) in western New Mexico and James Turrell's *Roden Crater* (1977–) in northern Arizona.[7]

Perhaps less widely known, and not immediately apparent to the general public, is Dia's patronage of a select group of artists during the foundation's early years.[8] The commitment to a generation that emerged in the late 1960s and 1970s reflected the founders' interest in artists from the United States and Europe (predominantly Germany) who questioned the status of the art object and installed work such that space and site are integral to its effect on the viewer. Through extensive material support, Dia engaged deeply with the members of its original roster to realize commissions as well as collect their art in depth. However, no traditional museum space intended as a repository for the collection existed, and instead the ambition was to establish singular sites, each dedicated to an individual artist or work. Dia acquired or rented studio spaces for artists and planned for (if not always realized) permanent displays of their work. Understanding the aesthetic potential of the industrial architecture of New York, Friedrich in particular identified, for purchase or lease, abandoned or defunct factories or commercial sites in Chelsea, SoHo, and Tribeca. Their size, sturdiness, and structural simplicity, along with the proclivity to repurpose existing architecture rather than build anew, came to define the characteristics of a Dia location, qualities that continue to delineate the institution's many spaces to this day.

Among the properties acquired at that time was the remarkable triple-height space for the *Dream House* (1979–85, p. 13) at 6 Harrison Street, a former mercantile-exchange building in Tribeca (p. 100). La Monte Young and Marian Zazeela's sonic-and-light environment also hosted regular performances of Young's radical, durational musical compositions.[9] Contemporaneously, from 1981 to 1985 Dia commissioned renowned North Indian classical musician Pandit Pran Nath, guru to Young and Zazeela, to familiarize the public with Kirana-style music. In addition, Dia acquired Young's original wood cabin home, Lot 4, Block 2, Bern, Idaho, a site where the sustained tones of the environment such as the wind and nearby electrical transformers legendarily inspired the musician's drone works. This period also saw the founding of the Fred Sandback Museum (1981–96, p. 100) at 74 Front Street, Winchendon, Massachusetts, in which the artist explored multiple configurations of his distinctive work, and Robert Whitman Projects (1979–85) at 512 West Nineteenth Street in Chelsea, a building acquired for Whitman to use in his multidisciplinary performances and installations and now occupied by another nonprofit art institution, the Kitchen.

Following John Chamberlain's move to Sarasota, Florida, in 1982, Dia maintained the artist's former studios in New York and Essex,

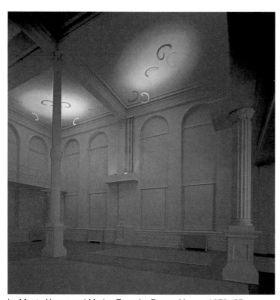

La Monte Young and Marian Zazeela, *Dream House*, 1979–85.
Sound-and-light environment, dimensions variable. Collection of the artists. Installation view, 6 Harrison Street, New York

Connecticut, turning them into sites for the long-term display of his work (p. 101). His former studio at 67 Vestry Street (p. 101) in Tribeca was an exhibition space between 1982 and 1985, and Dia supported an open-air Chamberlain sculpture garden on the Essex studio grounds from 1982 to 1984. In addition, an empty lot at 501 Broadway in the heart of SoHo was considered as a site for a De Maria outdoor garden. Other unrealized sites include 234 West Twenty-Third Street, built for the Cattlemen's Association and later occupied by Conklin Bass Company in Chelsea. It was intended to house the Cy Twombly Institute, a site dedicated to works by Twombly that were either part of Dia's collection or provided by the artist. Committed to the permanent display of the artist's work, in 1998 Dia went on to donate six of his paintings to the Menil Collection, Houston, in order to help found the permanent Cy Twombly Gallery (p. 103).

Another inaugural artist, Dan Flavin maintained an office at 186 Franklin Street, near the original foundation offices at 107 Franklin Street in Tribeca. In 1979 Dia acquired the ruins of Dick's Castle, built around 1903, in Garrison, New York, for the proposed Dan Flavin Art Institute. Within this sprawling site upstate, one wing was to display Flavin's collection of nineteenth-century Hudson River School landscape drawings, watercolors, and oil sketches. Plans were also made to present his fluorescent light sculptures and their associated studies, an archive, and a library of papers and books related to his work and that of the Hudson River School. While this project was not realized in that form and setting, Dia did successfully undertake many other installations with Flavin including *untitled* (1976–77, p. 98), a collaboration among the artist, Dia, and the Metropolitan Transit Authority (MTA) Arts for Transit and Urban Design at Grand Central Terminal, New York, from 1976 to 1987; the Flavin installation (1982–87, p. 15) at Masjid al-Farah, a mosque and exhibition space at 155 Mercer Street, SoHo, which Dia ran for the presentation of rituals and ceremonies, dance, prayer, and meditation; and the fully realized Dan Flavin Art Institute (now part of Dia Bridgehampton, pp. 30, 102), which was inaugurated in 1983 in Bridgehampton, New York, and houses a permanent installation of his work alongside a gallery for changing exhibitions.[10] Though it never came to fruition, between 1977 and 1982 Flavin worked with Dia, the Port Authority

of New York and New Jersey, the World Trade Center, and the MTA on an installation at the Thirty-Fourth to Fortieth Street subway concourse on the Sixth Avenue line in New York. Later, in 1996 Dia helped to make possible Flavin's permanent installation of work at Santa Maria Annunciata in Chiesa Rossa, Milan.

Between 1979 and 1986, Dia facilitated the expansive ambitions of Donald Judd to create what has become known as the Chinati Foundation (p. 99) in Marfa, Texas.[11] Helping to acquire the former army barracks and the thirty-one-acre site, which now holds installations of works by multiple artists, Dia also supported the fabrication of many of Judd's works made for the site, most notably the sculptures that constitute his one hundred untitled works in mill aluminum (1982–86). Judd's vision—to establish a site for the permanent installation of his work and that of others he admired, in a location that warranted a journey through the striking West Texas landscape—encapsulates the cultural ambitions that Dia looked to foster. A destination envisioned by Judd from beginning to end, it is also indicative of Dia's support for works made following an artist's deep engagement with a particular site or location such as the western United States. Never limited to the scope of New York, works supported by Dia were sited where the artist believed they should be

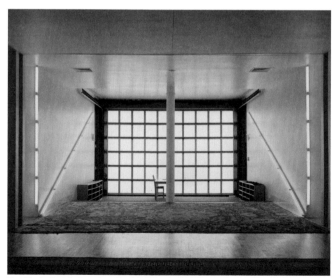

Dan Flavin, installation view, Masjid al-Farah, 155 Mercer Street, New York, 1982–87

for reasons of climate, geology, landscape, vernacular architecture, or other significance.

As is still evident in the four Dia sites dedicated to his work, De Maria achieved some of his most remarkable installations with the institution's support. *The Lightning Field*, a celebrated work of Land art in western New Mexico, took seven years to plan and realize, predating the actual founding of Dia. Installed in 1974 near Flagstaff, Arizona, the original *35-Pole Lightning Field*, a test run for the final work and also part of Dia's collection, was in fact funded by Virginia Dwan, who, along with Dia's founders, was one of the most important philanthropists supporting Land art at the time. Dia cofounder Winkler Fosdick and her partner Robert Fosdick moved to New Mexico to build the final project in the mid-1970s. With their help and that of several others, mostly locals, De Maria was able to produce a work characterized by a physical and material exactitude that defies this barren setting. Understanding the significance of time in the encounter and of the factors involved in viewer engagement, De Maria established a visitation protocol that calls for a specific journey through the adjacent landscape, an overnight stay, and a limited number of viewers at any given time. Like many works in Dia's collection, De Maria's projects reflect the importance of establishing a space for concentration and contemplation. This is no less true of his iconic works in SoHo, *The New York Earth Room* (1977, p. 52) and *The Broken Kilometer* (1979, pp. 56, 99), and in Kassel, Germany, *The Vertical Earth Kilometer* (1977, pp. 54, 99). No doubt facilitating an unusual encounter for many viewers in late 1970s SoHo with its declining industrial sector and the scattered Artist in Residence signs indicating the new occupants of the neighborhood's many aban-doned lofts, today these works sharply contrast with the commercial hubbub of downtown. *The New York Earth Room*, situated one floor up from the ground level of 141 Wooster Street, remains a timeless experience with a radical proposition: to simply fill an interior space with earth, creating an internal horizon line across the inaccessible expanse that observers may make of as they wish. *The Broken Kilometer*, located at 393 West Broadway, affords for first-time viewers both an unexpected engagement with geometry and an intense exposure to reflected light. Both spaces housed the gallery Heiner Friedrich Inc., which he had established in 1973 on arrival in New York from Munich. Originally on view in winter 1977

and spring 1979, respectively, *The New York Earth Room* and *The Broken Kilometer* eventually became Dia sites in perpetuity.

Expanded Presence

In recent years Dia has added sites that were neither part of its original commissions nor for the long-term placement of artist studios but were rather intended for the presentation of work on extended view through commission or exhibition. Among these spaces was Dia Center for the Arts at 548 West Twenty-Second Street (pp. 17, 102), opened in 1987, to be joined by nearby 545, which opened in 1992, and 535, acquired in 1993. The 548 building became identified with many major commissions by a later generation of artists including Stan Douglas, Katharina Fritsch (p. 18), Robert Gober, Ann Hamilton, Roni Horn, Pierre Huyghe, Tracey Moffatt, Juan Muñoz, Jorge Pardo, and Rosemarie Trockel. At 545 Dia commissioned works by such artists as Chantal Akerman, Bruce Nauman, Panamarenko, Richard Serra, and Hiroshi Sugimoto, while 535 was envisioned as a site for the collection but never realized as such. Dia's collection during this time was largely out of view and in storage at the Menil in Houston. Visitors could occasionally see selected holdings in these spaces on West Twenty-Second Street, including exhibitions of works by Chamberlain, Flavin, and Andy Warhol, but by and large the public remained in the dark about Dia's collection.

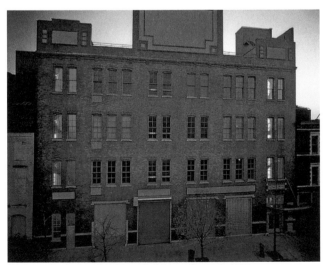

Dia Center for the Arts, 548 West 22nd Street, New York, 1996

Continuing a long relationship with the artist, Dia installed an extension of Joseph Beuys's project *7000 Eichen* (*7000 Oaks*, pp. 40, 102) along West Twenty-Second Street.[12] Originally commissioned as part of Documenta 7 in 1982 in Kassel, West Germany, and then funded in part by Dia, the project pairs basalt rocks with trees sited on a public street and is emblematic of Beuys's keen commitment to the early 1970s ecology movement. Following the initial New York City planting in 1988, more trees and stones were added in 1996 and 2021, and the permanent installation on West Twenty-Second Street continues the artist's radical vision for a communal artwork over multiple international sites.

A Home for the Collection

In 1999 Dia acquired a former Nabisco box and label factory in Beacon, New York, where it would finally showcase the collection to the public. Opening to visitors in 2003, Dia Beacon was envisioned as a place where many single-artist presentations could be contained under one roof. Designed by the artist Robert Irwin in collaboration with the architectural firm Open Office, Dia Beacon was intended to provide an ideal, naturally lit setting where the open spaces, rather than architect-designed galleries, would not impinge on the works themselves. Irwin extended the campus into the garden and the parking lot, creating a seasonally changing environment for art.

Staying true to the ambition to show work in depth, Dia Beacon gives over large spaces to both extended displays of a given artist's work

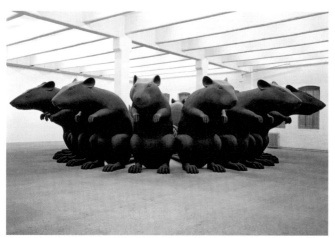

Katharina Fritsch, *Rat-King*, 1993. Polyester resin, 17 parts: 9 feet, 2¼ inches high × 42 feet, 7¾ inches diameter (2.8 × 13 m) overall. Emanuel Hoffmann Foundation, on permanent loan to the Öffentliche Kunstsammlung Basel (permanently installed at Schaulager, Basel), Zurich. Installation view, 548 West 22nd Street, 1993–94

produced over many years or to exceptionally large installations. As the holdings have grown, the displays have changed, but the focus of the collection remains largely, though not exclusively, on figures who emerged in the 1960s and 1970s (the dates of Dia's inception and concomitant involvement with a particular group of artists) and question the limits of the art object and its relationship to site. Among the permanent installations is Max Neuhaus's sound work, *Time Piece Beacon* (2005), his second to enter Dia's collection. The first, *Times Square* (pp. 76, 103), was originally installed in 1977 in the eponymous neighborhood, and in 2002 Dia worked with the MTA to establish this work as a permanent intervention, which consists of a harmonic sound texture emerging from the north end of the triangular pedestrian plaza located at Broadway between Forty-Fifth and Forty-Sixth Streets. Dia continues to maintain the site today, and along with the foundation's long-term involvement with Young, *Times Square* is one of many sound projects that Dia has fostered and maintained for decades.

Dia Beacon also advanced the commitment to choreography and dance first evinced at 155 Mercer Street in which space was made available for rehearsals, performances, and educational activities to hundreds of choreographers and dancers in the 1980s and 1990s. Such artists as Arthur Avilés, Molissa Fenley, Bill T. Jones, Ralph Lemon, Susan Osberg, David Parker, Lucia Pozzi, Sara Rudner,

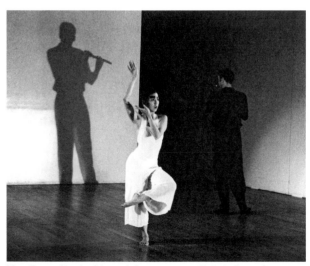

Muna Tseng, *Clouds of the 19th Century*, 1993, with flutist Bruce Gremo. Performance view, 155 Mercer Street, New York, 1993

Anna Sokolow, and Muna Tseng (p.19) presented their work at 155 Mercer. This engagement with dance has continued with both major performances at Dia Beacon by Merce Cunningham, Steve Paxton, Yvonne Rainer, and subsequent generations of dancers. The open spaces of the galleries offer great potential for realizing works adjacent to and in dialogue with the installations.

New Partners, New Sites
After the closure of Dia Center for the Arts in 2004, Dia collaborated with the Hispanic Society of America (p. 104), New York, from 2007 to 2011, installing a number of commissions that responded to their locations and, in many cases, extended across sites to Dia Beacon and the then–Dan Flavin Art Institute. Projects by Francis Alÿs (p. 20), Koo Jeong A, and Zoe Leonard took place over those years, continuing the foundation's long history of commissioning artists. Also of note, Dia developed and supported George Trakas's *Beacon Point* (2007, p. 104) in Beacon, New York; Thomas Hirshhorn's *Gramsci Monument* (2013, p. 104) in the Bronx; and Jennifer Allora and Guillermo Calzadilla's *Puerto Rican Light (Cueva Vientos)* (2015, p. 105) in a cave on the titular island, three major long-term projects in the landscape or urban fabric. The institution has also promoted cutting-edge work in the digital realm through Artist Web Projects, a commissioning series that began in 1995.

Francis Alÿs: Fabiola, installation view, Dia Art Foundation at the Hispanic Society of America, New York, September 20, 2007–April 6, 2008

In the years following Dia's original and significant support for Land art, its collection and stewardship of these sites has continued to grow. Through close collaboration with and the generosity of artist Nancy Holt, Dia was able to bring Robert Smithson's *Spiral Jetty* (1970, pp. 82, 85, 103) into its collection in 1999. Smithson's iconic work had been originally supported by Dwan and had for many years remained submerged under the water of the Great Salt Lake in Utah. With the reemergence of *Spiral Jetty* in 2002, Dia's stewardship of this work sited on public land has come to involve indispensable relationships with partnering organizations: the Great Salt Lake Institute, Salt Lake City; the Utah Museum of Fine Arts (UMFA), Salt Lake City; and more recently Holt/Smithson Foundation. Upon Holt's death in 2014, Dia also worked with Holt/Smithson Foundation to bring her *Sun Tunnels* (1973–76, pp. 62, 65, 105) into the collection, thus garnering greater recognition of this important work of Land art. The long-term preservation of *Sun Tunnels* entails collaboration with the foundation; Center for Land Use Interpretation, Wendover, Utah; and UMFA.

With the acquisition in 2011 of 541 West Twenty-Second Street, Dia was able to envision a new site for the institution in Chelsea. After years of experimentation in this space and at 545, Dia renovated the first floor of all three neighboring properties on West Twenty-Second Street to reopen the expanded Dia Chelsea in 2021 (p. 36). As with all other sites in the city, Dia Chelsea is free to all visitors in keeping with all of Dia's projects during its first twenty-nine years. This expansion is soon to be followed by the reopening of Dia SoHo in 2023, which will occupy a space at 77 Wooster Street that had historically housed works from the collection by Barnett Newman and Warhol, among others; was the venue for shows of work by Group Material and Martha Rosler (p. 101); and was subsequently rented out for many years.

Comprising eleven sites across the United States and Germany, Dia has witnessed several decades of changing locations, yet the essence of the institution has never been lost. As Friedrich has noted, "Dia is not about permanence, it's about presence—lasting presence."[13] At all Dia sites, even those that have existed since the 1970s such as *The Lightning Field*, resonance and meaning subtly change with each visit as our audience brings new information, states of mind, and contexts with them. As Dia faces its future, rife with possibility, it remains to be seen where the artists will take us.

1 The name stands in contrast with the majority of institutions devoted to modern or contemporary art, which adopt the descriptive nomenclature of periodicity or "newness," or the name of a founder or major donor.

2 Founding document, typescript of archive materials, DIAR.001, Early History records, 1974–1992 (bulk date 1974–1986), Dia Art Foundation Archives, Beacon, New York.

3 Dia was founded within a decade that witnessed the establishment of several art institutions in New York, among them, the Kitchen (1971), P.S. 1 Contemporary Art Center (now MoMA PS1, 1971), Artists Space (1972), and the New Museum of Contemporary Art (1977). Nonetheless, Dia has always stood out for its fidelity to these principles of time and the unmediated encounter.

4 Certificate of Incorporation: Restatement (original), 12 June 1985, DIAR.001, box 2, folder 19, Early History records, 1974–1992 (bulk date 1974–1986), Dia Art Foundation Archives, Beacon, New York.

5 In its early years, Dia's programs were located in two spaces in SoHo, one of which also housed the New York branch of Heiner Friedrich Inc. Dia inaugurated 141 Wooster Street (p. 98) in 1975 by supporting La Monte Young and Marian Zazeela's first *Dream Festival*, which included a *Dream House* sound-and-light environment from March 31 to April 27. With an exhibition of Blinky Palermo's *Times of the Day I–VI* (1974–76) in 1978, Dia began its programs at 393 West Broadway. Dia's offices at 107 Franklin Street in Tribeca were ultimately intended to house artworks, but this ambition was realized only once, with an exhibition of Walter De Maria's *Silver Meters* (1976) in 1977–78. Dia maintained offices at 107 Franklin Street from 1978 to 1985 for both its staff and those working on the translation of poetry by Velimir Khlebnikov, the institution's first publication.

6 Founding document.

7 For more information about sites affiliated with Dia, see "Time Line of Locations and Sites," in this volume, pp. 98–107.

8 Dia's original group of artists, whose work was either collected or supported, include Joseph Beuys, John Chamberlain, De Maria, Dan Flavin, Donald Judd, Imi Knoebel, Blinky Palermo, Barnett Newman, Fred Sandback, Cy Twombly, Andy Warhol, Robert Whitman, and Young and Zazeela.

9 A *Dream House* environment is still run by MELA Foundation at 275 Church Street in New York. In 2015 Dia acquired a version of the work, titled *Dia 15 VI 13 545 West 22nd Street Dream House*, which was conceived for Dia Chelsea by Young and Zazeela with Jung Hee Choi.

10 Alexander Keefe, "Whirling in the West: On DIA and/as Spiritual Conspiracy," *Bidoun*, no. 23 (Winter 2011), https://www.bidoun.org/articles/whirling-in-the-west. Dia acquired 155 Mercer Street in 1978. Together with Sheikh Muzaffer Ozak Ashki al-Jerrahi, leader of the Halveti-Jerrahi Order of Dervishes of Istanbul, the foundation established the Sufi lodge, Masjid al-Farah, open to the public from 1981 to 1986. Flavin's series of untitled light sculptures, commissioned by Dia, were on view throughout the space from 1982 to 1987.

11 Originally this was to be called El Museo de Arte del Pecos (the Art Museum of the Pecos).

12 Dia's relationship with Beuys extends back to Friedrich's time as an art dealer in Germany and has resulted in significant holdings of the artist's work in the collection.

13 Dodie Kazanjian, "Meet the Visionary Curator Who's Transforming Dia Art Foundation," *Vogue* (February 23, 2016), https://www.vogue.com/article/jessica-morgan-dia-art-foundation-director.

Dia Art Foundation 107 Franklin Street New York, New York 10013 212-431-9232

NEW YORK MUSEUM - a museum concept

New York Museum is what we are currently calling our plan
for the establishment of individual and independent spaces
in New York City. These spaces will serve as alternatives
to the existing institutions in New York City and the estab-
lished practices of galleries and museums. This new museum
is intended foremost to compliment all valuable efforts
of representation of the powerful visual arts of the 20th
century.

The works of singular artists of high importance are to
be seen on permanent exhibition. The works are to be chosen
and installed in close collaboration with the artist. They
will be presented in their own context, with no interference
of works of other artists or institutional distractions.
These spaces will be independently accessible so that the
impact of the experience will be maintained throughout the
visit. They will exist in a lasting timespan which will
allow them to become a permanent part of the cultural
tradition of the 20th Century. The spaces will be cared
for by trained people in close consultation with the artists.
They will be administered and curated from a central office,
whereas each space will be individually guarded and maintained.

The concept of independent one-artist museums and spaces
is not a new one. Its history can be traced throughout
the development of the mainstream cultural tradition, and
is evidenced in chapels and sacred spaces of the past;
through the cultural and historical environment of the
Renaissance; and on to the established galleries of individual
artists within major museums. We feel this form of presentation
will best continue the tradition of the art of the last
half of the 20th Century.

"New York Museum—a museum concept," ca. 1974–85. Dia Art Foundation Archives, Beacon, New York

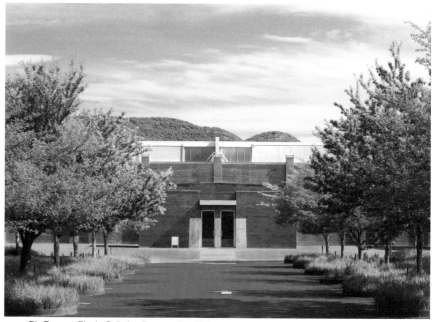

Dia Beacon, Riggio Galleries, Beacon, New York

Dia Beacon
Riggio Galleries
3 Beekman Street
Beacon, New York

Dia Beacon opened on the banks of the Hudson River in Beacon, New York, in May 2003. The museum is housed in a converted box- and label-printing factory that was purchased in 1999 as a permanent home for Dia's expanding collection of art from the 1960s to the present, as well as special exhibitions, performances, and public programs. The galleries feature a combination of permanent interventions, such as Michael Heizer's *North, East, South, West* (1967/2002), Gerhard Richter's *6 Gray Mirrors* (2003), and Richard Serra's Torqued Ellipses (1996); long-term, multiyear displays; and temporary installations and activations. The museum thus offers viewers the possibility for sustained, repeated, and novel aesthetic encounters.

Dia Beacon belongs to Dia's long tradition of renovating industrial warehouse spaces, rather than constructing new buildings, for the display of artworks. At the turn of the twenty-first century, Beacon was one of many economically depressed, postindustrial towns in the Hudson Valley. The site was chosen because of its expansive exhibition and storage space, its connection to New York's West Chelsea neighborhood via the railway, and the region's historical associations with the nineteenth-century landscape painters of the Hudson River School, who are an important reference point for several artists in the collection.[1] This connection is in part what had endeared Dan Flavin to the Hudson Valley, and why Dia purchased nearby Dick's Castle, intended as a permanent site for Flavin's work in the 1970s.

Built in 1929 by the National Biscuit Company (known as Nabisco since 1949), the former label- and carton-production plant was originally designed by Nabisco's staff architect Louis N. Wirshing Jr. and is a model of efficient, early twentieth-century industrial architecture. The nearly 300,000-square-foot building features steel and concrete columns, reinforced maple and cement flooring—originally constructed to support heavy

machinery—and soaring ceilings illuminated by clerestories and skylights. The bones of the building, therefore, offer the ideal structure to house Dia's growing collection of large, often heavy, installations, paintings, and sculptures.

Dia commissioned the artist Robert Irwin and the architectural firm Open Office to reconfigure the rundown building and its grounds as a museum. Irwin's interest in what he describes as "conditional" art or architecture—which has "no beginning, no middle, no end to it," but rather offers visitors a set of navigational choices while in the museum—closely aligns with Dia's long-standing curatorial approach, which posits that each artist's work should be seen on its own terms.[2] As a result, each of Dia Beacon's vast galleries was designed to present the work of one artist at a time. Rooted in Dia's founding commitment to helping artists realize in-depth displays, the installations are designed in close collaboration with the artists whenever possible.

Conceiving of Dia Beacon as a work of art in and of itself, Irwin's *Beacon Project* (1999–2003) made subtle interventions into the building's lighting and developed a symmetrical floor plan to ensure that the galleries are presented nonhierarchically and without a single overarching historical or chronological narrative. He had panels of clear glass installed within the grids of frosted windows that run along the museum's east and west facades. As the sun rises and sets over the course of the day, this ethereal intervention into the window treatment casts shadows that move, like a sundial, across the building and allow direct sunlight to shine into the galleries. At ground level, open central axes bisect the museum from north to south and east to west, creating sightlines from one end of the building to the other. These linear interventions divide the museum into quadrants that are further configured into individual galleries.

Irwin determined that because Dia Beacon is located along the Metro North Railroad and many visitors would be traveling from the city, for them, the experience of the museum often starts at Grand Central Terminal—the departure point of the train. As a result, he envisioned the museum as a "sequence of experiences"

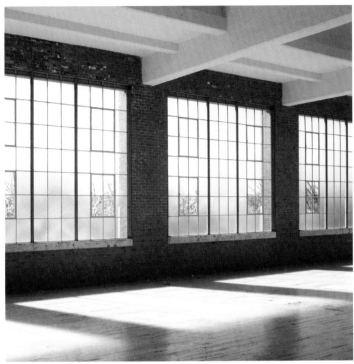

West corridor

Fred Sandback, *Untitled (from Ten Vertical Constructions)* (detail), 1977–79; background: Michael Heizer, *North, East, South, West* (detail), 1967/2002

27

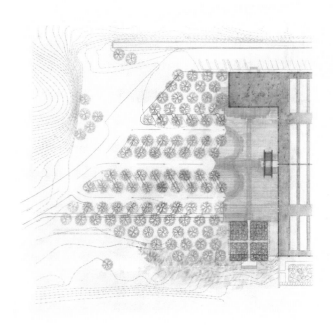

Robert Irwin, *Rendering of forecourt for Dia:Beacon*, 2001. Graphite and colored graphite on vellum, 36 × 36 inches (91.5 × 91.5 cm). Dia Art Foundation

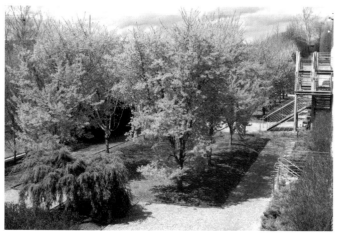

West garden, 2008

including riding the linear corridor of the train tracks up the Hudson River, descending into Dia Beacon's parking lot, and entering the facility.[3] While working on *Beacon Project*, Irwin lived in the town of Beacon and studied its horticulture and seasonal light conditions. Taking these elements into consideration, Irwin's design for the surrounding landscape incorporates traditional, local plants that offer viewers something of interest in all four seasons. A canopy of hawthorns and crab apples in the parking lot extends the horizontal plane of the building's roof, while porous paving blocks made of Glasscrete on the front grounds interweave the museum's architecture, including Irwin's addition of an entry vestibule, with its natural setting. Considering the possible ambulatory paths one could take through the campus, Irwin designed a garden on the museum's west side to serve as a bridge between otherwise unconnected parts of the building. In all, the design maintains the character of the original structure and ensures that Dia Beacon's expansive galleries are entirely lit by natural light. Moreover, the renovation was specifically envisioned for the display of the works in Dia's collection, many of which, because of their character or size, could not be easily accommodated by more conventional museums.

1 Beginning in the 1930s, the train line ran through the former Nabisco factory all the way into New York via what is now known as the High Line, where it stopped at the company's enormous bakery, housed in what is now Chelsea Market. See Katherine Martinelli, "The Factory That Oreos Built," *Smithsonian Magazine*, May 21, 2018, https://www .smithsonianmag.com/history/factory-oreos -built-180969121.

2 Robert Irwin, "Oral History Interview with Robert Irwin, 2013 February 9–May 11," interview by Matthew Simms, transcript, Archives of American Art, Smithsonian Institution, Washington, DC, https://www.aaa .si.edu/download_pdf_transcript/ajax?record _id=edanmdm-AAADCD_oh_366562. See also Matthew Thomas Simms, "Conditional Gardens and Aesthetic Novelty," in *Robert Irwin: A Conditional Art* (New Haven: Yale University Press, 2016), p. 252.

3 Ibid., p. 239.

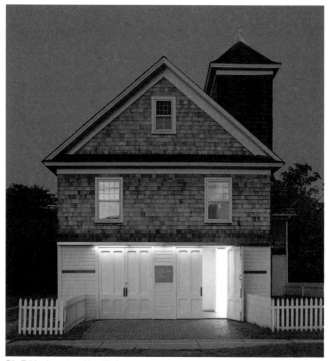

Dia Bridgehampton, New York

Dia Bridgehampton
The Dan Flavin Art Institute
23 Corwith Avenue
Bridgehampton, New York

Located at 23 Corwith Avenue in the coastal town of Bridgehampton, New York, Dia Bridgehampton was designed by artist Dan Flavin to permanently house an installation of his work alongside a program of temporary exhibitions. With Dia Art Foundation's support, Flavin renovated this turn-of-the-century Shingle-style firehouse, then church, converting its vestibule and second floor into a display of his signature works in fluorescent light. A resident of nearby Wainscott, Flavin envisioned that the first floor would be both a venue for changing exhibitions and a printshop for himself and other artists working on Long Island.

Unadorned and clearly structured, Dia Bridgehampton's vernacular architecture has been carefully altered over time to best serve its successive purposes. Between 1908 and 1923, the property was occupied by the Hook and Ladder Company, the town's volunteer fire department. The First Baptist Church of Bridgehampton bought the property in 1923, and the Prince Hall Freemasons laid a new cornerstone on the church's behalf in 1947, when renovations began on the building.[1] The facade was extended, and the main entrance moved from the front to the side. An annex was built to house a garage on the first floor and an apartment on the second. When the congregation grew too large for the premises in 1979, a new church was erected nearby, and Dia purchased the property to present Flavin's art.

Working closely with architect Richard Gluckman and Dia's director of operations James Schaeufele, Flavin oversaw the building's renovation between 1981 and 1983, making key decisions to best accommodate his work and preserve the property's multiple legacies. Protruding facade elements such as gutters and electrical cables were removed to streamline the exterior. Doors, paneling, and shingles were restored, and an ethereal blue light was installed under the front cornice. To best modulate the light indoors, the artist ordered ultraviolet-filtered

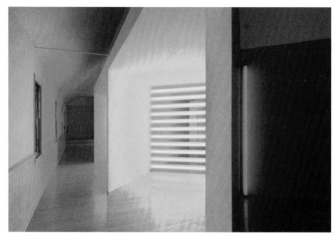

Dan Flavin, *nine sculptures in fluorescent light* (detail), 1963–81. Fluorescent light and metal fixtures, dimensions variable. Installation view, the Dan Flavin Art Institute at Dia Bridgehampton

glass windows and gray Mylar shades. To memorialize the building's initial function, the barn-style double doors from the firehouse entrance were refurbished and the newel post in the vestibule was painted fire-engine red. The church doors and frosted-glass windows were moved to the back room of the second floor, which hosts a display of memorabilia from the First Baptist Church including a neon cross. The building opened to the public as the Dan Flavin Art Institute on June 18, 1983. In keeping with his practice of acknowledging friends, relatives, curators, or historical personages in the titles of his work, Flavin dedicated the building to Schaeufele.

The vernacular frame protects an intimately sized yet sensorially rich interior, where natural light blends with Flavin's buzzing fluorescent works. Selected and arranged by the artist, *nine sculptures in fluorescent light* (1963–81) offers an inventory of the possibilities for readymade colored light in relation to architecture. Composed of circular fluorescent fixtures in three temperatures (cool, daylight, and warm) of white, *untitled (to Jim Schaeufele) 1, 2,* and *3* (all 1972) punctuate the ascent up the vestibule's staircase. A preparatory drawing

from Flavin's "icons" series, *untitled [drawing for icon IV (the pure land) (to David John Flavin 1933–1962)]* (1962), is the first piece that visitors encounter when they reach the second-floor landing. In the main gallery, Flavin devised a structure composed of walls set at 90-degree angles to display a selection of his lights. At each end of this structure are four works that explore the possibilities of colored light in relation to corners with increasing degrees of complexity. In *red out of a corner (to Annina)* (1963), a single red fixture doubles the corner that hosts it, while in *untitled* (1976), a bundle of three variously colored fixtures leans into a corner. In *untitled (to Katharina and Christoph)* (1966–71) and *untitled (in honor of Harold Joachim) 3* (1977), vertical and horizontal fixtures create a square and grid, respectively, illuminating both the corners and the viewer.

The central portion of the wall construction supports two corridors barred at their center. Flavin wanted the fluorescent fixtures to face both directions so that they would illuminate the viewer and the inaccessible half of the corridor beyond the barriers. In *untitled (to Robert, Joe and Michael)* (1975–81), horizontal bulbs—gold on one side, pink on the other—span the width of a corridor, blocking physical passage but not visual access. The pink is intensified toward purple when viewed from the gold side, while the gold gains a greenish tint when viewed against the pink. Similarly, *untitled (to Jan and Ron Greenberg)* (1972–73) takes the form of a barrier, although here the lights are installed vertically—green bulbs on one side and yellow on the other. In this work, the blockage is incomplete; one fixture is absent, allowing a glowing edge of yellow to penetrate the green side of the corridor.

The inaugural exhibition in the ground-floor gallery featured Flavin's first work using fluorescent light fixtures, *the diagonal of May 25, 1963 (to Constantin Brancusi)* (1963) with a set of preparatory drawings. In addition to overseeing the building's renovation, the artist took an active role in curating several early programs, which featured his and other local artists' work, pieces from his collection of nineteenth-century Long Island arts and

Mary Heilmann: Painting Pictures, installation view, the Dan Flavin Art Institute, Bridgehampton, New York, June 29, 2017–May 28, 2018

crafts, Japanese drawings and prints, and Hudson River School drawings. Starting in 1987, independent curator Henry Geldzahler advised Dia on a series of monographic exhibitions featuring artists with ties to the East End of Long Island such as Louise Bourgeois, Alice Neel, Cy Twombly, and Andy Warhol. Today, Dia continues to present yearly exhibitions of artists primarily residing or working on Long Island in the space, including Mary Heilmann and Jill Magid.

Part of the rich cultural history of the East End, Dia Bridgehampton is a lasting example of Dia and Flavin's collaborative vision and shared preoccupation with site-specificity. The location remains a testament to the compelling experience generated by a concentration of the artist's light works in a carefully calibrated setting. As fellow artist Dan Graham stated, in the simplicity of Flavin's fluorescent variable, "light is immediately present in all places."[2]

1 In February 1947 the growing congregation
 voted to build a new church, but the reverend
 at the time decided to renovate the building
 instead. A cornerstone—later detached and
 preserved on the second floor of Dia
 Bridgehampton—was laid by Tyre Lodge
 No. 91. F. & A. M., a chapter of the Prince
 Hall Freemasonry, also known as the African
 American Freemasonry. Considered one of the
 most influential Black leaders of the late 1700s,
 Prince Hall (ca. 1735–1807), the founder, was an
 abolitionist known for his leadership in the free
 Black community of Boston and was active in
 the Back to Africa movement. The chapter is
 still active today.
2 Dan Graham, "Flavin's Proposal," *Arts Magazine*
 44, no. 4 (February 1970), p. 44; quoted in
 Michael Govan and Tiffany Bell, *Dan Flavin:
 The Complete Lights, 1961–1996* (New York:
 Dia Art Foundation, 2004), p. 72.

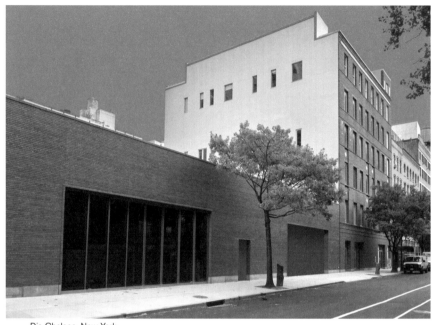

Dia Chelsea, New York

Dia Chelsea
537 West 22nd Street
New York, New York

Dia Chelsea consists of three adjacent properties connected at street level, located on the north side of West Twenty-Second Street between Tenth and Eleventh Avenues. Walking toward the Hudson River from Tenth Avenue, one finds a bookstore and public programs space followed by two expansive galleries for changing exhibitions. The walk is punctuated by pairings of trees and basalt columns from Joseph Beuys's project *7000 Eichen* (*7000 Oaks*, pp. 36, 40, 102), planted and maintained by Dia Art Foundation in Chelsea starting in 1988. Built in the mid-twentieth century to serve as warehouses for the manufacturing port of West Chelsea, Dia Chelsea contains single-story, single-span galleries that are characterized by their industrial size and the natural light that filters through the skylights. The galleries were renovated over time by Dia to present commissions and focused exhibitions on long-term view.

Dia's established presence in West Chelsea dates to 1987, when the foundation consolidated its exhibition programs into a four-story masonry warehouse at 548 West Twenty-Second Street.[1] Today an affluent part of the city, the neighborhood was a waning industrial center facing a drastic population decrease when Dia moved to the area.[2] While Dia and the Kitchen were the only art institutions in the neighborhood in the 1980s, by the late 1990s major commercial galleries and nonprofits had replaced much of the heavy industry in the area. In 2004, when Dia paused its programming in Chelsea to focus on the new facility in Beacon, New York (pp. 24, 27, 28, 104)—another repurposed industrial building—the city formally approved the Special West Chelsea District zoning resolution, which prepared the neighborhood for commercial and residential developments.[3]

Beginning in 1982, Dia renovated 548 West Twenty-Second Street in collaboration with architect Richard Gluckman to accommodate an expanded artistic program. With abundant

Dan Graham: Rooftop Urban Park Project, installation view, Dia Center for the Arts, New York, September 12, 1991–January 11, 2004

natural light filtering in from windows around the perimeter, each 8,000-square-foot level had an open plan with columns plotted on a grid. The building opened to the public on October 9, 1987, with each of its three floors dedicated to a presentation of works in the collection by Beuys, Imi Knoebel, and Blinky Palermo, respectively.

Following Dia's history of supporting artists' projects outside traditional institutional spaces, programs at this location set the current model for Dia Chelsea. Each artist was offered one floor, and works from the collection alternated with newly commissioned single-artist presentations, all on display for extended periods of time. Occasionally works by two artists were placed in dialogue. At times, the commissions took the form of site-specific installations. Between 1991 and 2004, Dan Graham's *Rooftop Urban Park Project* (1991) transformed the roof of 548 into a small urban park for the local community. The project featured a large glass pavilion and a shed, which was converted into a cafe and video-viewing room programmed by the artist. In 1996 Dan Flavin's *untitled* (1996) was installed in the corners of the building's stairwells. Invited to refurbish the first floor in 2000, Jorge Pardo conceived a multipart installation including a bookstore

focused on postwar and contemporary art and culture, theory, history, and poetry, as well as presentations of video work courtesy of Electronic Arts Intermix.

Dia's presence in the neighborhood gradually evolved over the course of the 1990s to include the three buildings across Twenty-Second Street that currently constitute Dia Chelsea, while 548 permanently closed to the public in 2004 and all of its site-specific works were relocated. The gallery at 545 West Twenty-Second Street opened in 1997 with an exhibition of Richard Serra's Torqued Ellipses (now on permanent view at Dia Beacon), and the fifth floor of the adjacent building, 535, hosted Dia's public programs between 2005 and 2019. The latest addition, 541, opened to the public in 2012 with a presentation of Thomas Hirschhorn's work of the same year, *Timeline: Work in Public Space*. In 2020, in collaboration with the Architecture Research Office (ARO), Dia renovated and expanded these properties, adding a bookstore and public programs space to the street level of 535 and adjoining the galleries at 541 and 545, now under the single address 537. In 2021 this integrated 32,500-square-foot space opened to the public with a commission by Lucy Raven. The renovation maintained the industrial character of the buildings while structurally improving them for the purpose of exhibiting artworks. The buildings' facades, layouts, and skylights were preserved to ensure abundant space and natural light. Lectures, panels, poetry readings, screenings, and an arts-education program continue to complement ambitious presentations at Dia Chelsea, furthering the institution's commitment to contemporary culture and criticism at large.

1 Between 1979 and 1985 Dia maintained a studio and exhibition space at 512 West Nineteenth Street for the artist Robert Whitman.

2 In the late 1960s, containerization—the transition to the use of shipping containers to transport goods—hastened the decline of nearby ports while the elevated freight line on Tenth Avenue (now the High Line) was abandoned. Since West Chelsea consisted primarily of worker tenements for those employed at the port, estimated employment rates, educational attainment, and median household incomes dropped lower than those of broader Chelsea and Manhattan as a whole over this period. Michael Frisch, "Art and Urban Development: The Case of West Chelsea" (paper, Association of Collegiate Schools of Planning annual conference, Cleveland, November 2001).

3 Julia Rothenberg, "Selling Art to the World in Chelsea," *Visual Studies* 27, no. 3 (November 2012), p. 286. See also Jeremiah Moss, "Disney World on the Hudson," *New York Times*, August 21, 2012, https://www.nytimes.com /2012/08/22/opinion/in-the-shadows-of-the -high-line.html.

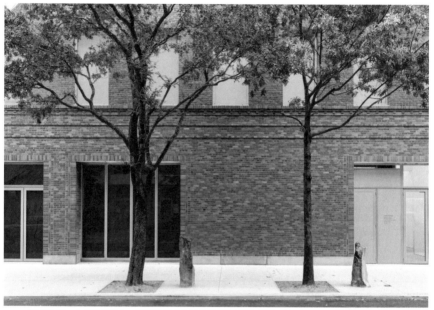

Joseph Beuys, *7000 Eichen* (*7000 Oaks*) (detail), West 22nd Street between and including 10th and 11th Avenues, New York, inaugurated in 1982 and ongoing. Trees and basalt, dimensions variable. Dia Art Foundation

Joseph Beuys, *7000 Eichen* (*7000 Oaks*), inaugurated in 1982 and ongoing
West 22nd Street between and including 10th and 11th Avenues
New York, New York

7000 Eichen (*7000 Oaks*) is an international public project by Joseph Beuys, who was born in Düsseldorf in 1921. With major support from Dia Art Foundation and under the auspices of the Free International University (FIU)—an experimental pedagogical organization cofounded by Beuys in Düsseldorf in 1973—the artist initiated *7000 Oaks* in Kassel, West Germany, in 1982, as part of the quinquennial international art exhibition Documenta. Beuys intended for the Kassel initiative to be the first stage in an ongoing project to plant trees throughout the world as part of a global mission to spark environmental and social change, and Dia extended the project to New York City in 1988. Located on the same block as Dia Chelsea and the institution's administrative offices, this portion of *7000 Oaks* now consists of thirty-eight living trees, each paired with a columnar basalt marker measuring four feet tall.

In preparation for Documenta 7, Beuys arranged in early 1982 for basalt to be brought into Kassel from a quarry outside the city, which was then amassed on the front lawn of the Fridericianum, Documenta's primary exhibition building. Beuys himself planted the first tree with its accompanying stele. The planting continued over the next five years under the aegis of the FIU. Trees and stones were arranged according to site proposals submitted by residents, neighborhood councils, schools, local associations, and other groups. At the opening of Documenta 8 in June 1987, some eighteen months after Beuys had died, the artist's son, Wenzel, and widow, Eva, planted the last tree in Kassel, matching the nominal seven thousand. While the majority of the trees were oaks, fifteen other species were incorporated.

"*7000 Oaks* is a sculpture referring to peoples' lives, to their everyday work," Beuys once said. "That is my concept of art, which I call the extended concept of art or social sculpture."[1]

Both notions were crucial to the artist's practice. For Beuys, the "extended concept of art" indicated that any material or action (like planting a tree) could be considered a work of art, while "social sculpture" signified art's capacity to shape new social worlds and forms of collectivity. For the artist, activism, pedagogical endeavors, public actions, and even media appearances could all belong to an artistic practice.

The related issues of ecology and collectivity foregrounded in *7000 Oaks* constitute a recurring thread in Beuys's work. In 1964 the artist made a spade with two handles, *Gemeinschaftsspaten* (*Community Spade*) for the Fluxus action *24 Stunden* (*24 Hours*) on June 5, 1965, at Galerie Parnass in Wuppertal, West Germany. "Two handles on one spade signify a special kind of compound action for people working the earth together," the artist noted.[2] A decade later, the founding FIU manifesto declared that "it is no longer regarded as romantic but exceedingly realistic to fight for every tree, every plot of undeveloped land, every stream as yet unpoisoned."[3] Those earlier propositions materialized in public actions at the turn of the 1980s. Beuys's Pescara, Italy, project *Fondazione per la rinascita dell'agricoltura* (*Institute for the Rebirth of Agriculture*, 1978) initiated collective tree planting as a specific group of actions based on a concept of agriculture outside science or economic profit.[4] In parallel, Beuys began organizing *7000 Oaks*.

Unlike previous local actions, Beuys always intended *7000 Oaks* to spread around the world. Dia was an early supporter of the project, formalizing a joint venture agreement with the FIU in March 1982 to help fund the piece. In 1987 Dia opened a new exhibition space at 548 West Twenty-Second Street with three simultaneous exhibitions of works by Beuys, Imi Knoebel, and Blinky Palermo. As part of celebrations that unfolded over the course of the year following the new building's inauguration, Dia installed five trees and columns on West Twenty-Second Street, bringing *7000 Oaks* to New York. Per Beuys's original instructions, the basalt was imported from the same quarry that had supplied the Kassel manifestation. *7000 Oaks* was further

expanded in 1996 to run the length of the entire block between Tenth and Eleventh Avenues.[5] Coinciding with the renovation of Dia Chelsea in 2020–21, one more pair was added, bringing the total to thirty-eight. In keeping with the variety of the Kassel plantings, the species include Callery pear, common hackberry, gingko, Japanese pagoda, littleleaf linden, pin oak, sycamore, thornless honey locust, and zelkova—hardy species capable of withstanding the stresses of the urban environment.

7000 Oaks is both site-specific and completely transposable, bound to the germination period of trees yet designed to alter future ecologies. Beuys's idealism has carried forth in the broader life of the project. It has inspired similar plantings, official or otherwise, in Baltimore, Minneapolis, Oslo, and Sydney, among other locations, and the Stiftung 7000 Eichen continues to operate in Kassel, where it supports and maintains the project. In times of ecological crisis, it becomes clear that seven thousand is only a nominal limit. As Beuys once said in a typically expansive register: "I believe that planting these oaks is necessary not only in biosphere terms, that is to say, in the context of matter and ecology, but in that it will raise ecological consciousness—raise it increasingly, in the course of the years to come, because we shall never stop planting."[6]

1 Joseph Beuys, quoted in Karl Heinrich Hülbusch and Norbert Scholz, *Joseph Beuys: 7000 Eichen zur documenta 7 in Kassel* (Kassel, West Germany: Kasseler Verlag, 1984), p. 31. Quote translated by Joseph P. Henry.

2 Joseph Beuys, *Joseph Beuys*, ed. Caroline Tisdall, (New York: Solomon R. Guggenheim Foundation, 1979), p. 204.

3 Joseph Beuys, *Energy Plan for the Western Man: Joseph Beuys in America*, comp. Carin Kuoni (New York: Four Walls Eight Windows, 1993), p. 151.

4 Benjamin Dodenhoff, "1979–1983," in *Joseph Beuys: Parallel Processes*, ed. Marion Ackermann and Isabelle Malz (Düsseldorf: Kunstsammlung Nordrhein-Westfalen; Munich: Schirmel/Mosel, 2010), p. 255.

5 The expansion was completed in partnership with the New York City Department of Parks & Recreation, the New York Tree Trust, and the Arthur Ross Foundation. Additionally, permits to make changes to the sidewalk were acquired from the city's Department of Transportation, which was also Dia's partner in presenting the project to the city's design review agency, Art Commission, New York. While Dia maintains *7000 Oaks* in Chelsea, the work is a long-term loan to the city of New York.

6 Beuys, quoted in *Beschreibung eines Kunstwerkes: Joseph Beuys, 7000 Eichen*, ed. Johannes Stüttgen, trans. Bruni Mayor (Kassel, West Germany: Sander, 1982), p. 1.

FURTHER READING

Beuys, Joseph. *Energy Plan for the Western Man: Joseph Beuys in America.* Compiled by Carin Kuoni. New York: Four Walls Eight Windows, 1993.

Cooke, Lynne, and Karen Kelly, eds. *Joseph Beuys: Drawings After the Codices Madrid of Leonardo da Vinci.* New York: Dia Art Foundation, 1987.

Mesch, Claudia, and Viola Michely, eds. *Joseph Beuys: The Reader.* Cambridge, Mass.: MIT Press, 2007.

Scholz, Norbert. "Joseph Beuys: 7000 Eichen in Kassel = 7000 chênes à Kassel = 7000 Oaks in Kassel." *Anthros: Zeitschrift für Landschaftsarchitektur* 25, no. 3 (September 1986), pp. 31–35.

Tisdall, Caroline, ed. *Joseph Beuys.* New York: Solomon R. Guggenheim Foundation, 1979.

<div style="text-align:center">

Joseph Beuys
Excerpts from 7000 Eichen *brochure* (1982)

</div>

These excerpts from a 7000 Eichen *(*7000 Oaks*) brochure by Johannes*
Stüttgen of the Free International University include quotations from
Joseph Beuys about the project as well as a selection from "Conversation
on Trees," an interview between the artist and Bernhard Blume in Bonn,
West Germany, on April 24, 1982.

JOSEPH BEUYS: The planting of *7000 Oaks* is thus merely a symbolic beginning. And to mark this symbolic beginning I also need a *boundary stone*, namely, these basalt columns. This action is meant to point toward a transformation of life as a whole, society as a whole, the whole ecological space. . . .

So with these first 7000 trees what I was looking for was a kind of monumentality, with each individual monument consisting of a living part, namely the NATURAL ENTITY TREE, constantly changing in time, and another part that's crystalline, preserving its shape, volume, size, and weight. If anything about the stone does change, then it is only by removal—a piece being broken off—never by growing. The juxtaposition of these two parts of the monument produces a constantly changing proportion between the two. At the beginning, when we have six- or seven-year-old oak trees, the basalt columns almost dominate them. After a couple of years, an equilibrium between the basalt and the tree will be reached, and after, say, twenty or thirty years, we will perhaps see the stone gradually turning into a subsidiary structure at the foot of the oak or other respective tree.

Conversation on Trees[1]
BEUYS: I already indicated what's new at the beginning when I said [*7000 Oaks*] was about constructing a new cultural shell around the planet Earth. The biosphere, as an essential atmosphere that's healthy and suited to satisfy human needs in a biological sense, is naturally part of this shell, this new shell-quality. But I certainly don't mean to say that the process will finish

there: we must continue to pursue the socio-ecological integration of all forces in society until we reach a mode of thinking in the spheres of culture, politics, and economy. It's about developing a new idea of capital, one that above all is concerned with what's inside us. . . .

AUDIENCE: But why specifically oak trees? Why not other trees?

BEUYS: No, no, it's not about that! I did say "trees" before, you know! Even so, I didn't want to be arbitrary about it, did I. I wanted to take a tree that could provoke all these questions. A black locust tree, for instance, wouldn't have called up any associations with any kind of religious, spiritual, or historical questions at all. Black locusts (*Robinia pseudoacacia*) have grown in mixed woods in our country since the Ice Age, but they've never had any special significance. We wanted a tree that could best carry the freight of all these questions, and we don't want to be dogmatic about it. Above all, we don't want to just start planting something where it won't grow! So we'll eventually extend it to plane trees, trees that adapt to certain urban situations one way or another, like gingkos, a fossil that lives on, having survived all the, let's say, ice ages, volcanic eruptions, every disaster known to geology that nature has undergone from the Cretaceous Era to today, it adapts to everything. That's the ginkgo. We'll plant those too!

AUDIENCE: Why the oak in particular? It seems to me that the oak really does have kind of an overtone of Germanness and the German past and nationalist feelings. If you'd chosen the ginkgo, wouldn't that have been much nicer as a symbol, precisely with its ability to survive all disasters, pointing to the future!

BEUYS: But that would just be avoiding this so-called "German question"! When what we need to do is resolve it once and for all, in connection with the questions that many peoples contain within themselves, as fundamental spiritual questions. . . . We want to develop this new warm-time machine, something very different from the methods of some bygone mysticism of a misunderstood Germanness. . . .

AUDIENCE: Can we be optimistic enough to think that trees will even still exist at all in fifty or a hundred years?

BEUYS: Yes, well, optimism doesn't really have much to do with what's necessary! Our actions must be based neither on optimism nor on pessimism. If we allowed ourselves to be influenced by such emotional stimuli, prompting

either like or dislike, we wouldn't be able to do anything reasonable anymore. But it says right here on [Bernhard] Blume's stamp: "Pure reason is green!" It says so right there! That means: We can't let ourselves be guided by likes and dislikes! Only by what the moment demands. . . .

For this reason I don't entirely agree with Blume when he says that the artist, or art, can't develop a professional ecology—I say exactly the opposite, that the concept of the "professional" has to be given extra special scrutiny. For if we mean by "expert" or "professional" someone with the ability to judge some detail in isolation from a general problem, then I am all in favor of that kind of science or specialized knowledge. But this type of science has always existed, ever since the emergence of science in general. And it's demonstrably true that precisely such scientific professionalism has destroyed the planet and human health. That's why we believe only art can develop the overarching expertise or professionalism needed to take this subdivided specialization in biology, in forestry, or in dendrology, the study of trees—the whole sphere of the tree problem in other words—or the branch of chemical processing that utilizes cellulose from trees—that only art can develop such an overarching idea of ecology and professionalism! In the sense that art alone is the only revolutionary force that can change the world, humanity, the social system, etc. Because at the present time none of the evolutionary strides made in history, including those of the emergence of the idea of exact sciences, can overcome this main problem. What we need is a truly human and humane means of carrying out the revolution, that is, the complete transformation of the sick into the healthy. And in my opinion, this means can only be art. Only in this framework does it makes sense that, at a particular point in time, after all the other experiments that have been attempted in the past (like for example those in Kassel: working on the question of democracy, for instance, as a social question and as an ecological question, in 1972, with the ORGANIZATION FOR DIRECT DEMOCRACY and its "100 Days," and then, at the most recent DOCUMENTA with the FREE INTERNATIONAL UNIVERSITY, specifically on the overall shape of the social system organized around a new concept of capital)—so it's logical to now start entirely from physical construction, too, which represents so to speak "the modern," and move toward where people bear this expanded concept of art at their workplaces and in their living spaces, in the sense that every person is an artist or at least

should and must be seen as one, because human creativity is the real social capital, and on the basis of this logic of capitalism and communism—the two ways that a bygone, out-of-date understanding of capital, which still understands capital as money, plays the game—it must be transformed into an idea of capital that we need to keep firmly in mind: that human capacities are the capital of humanity.

AUDIENCE: I wonder how putting up monuments, how art in general, can possibly accomplish anything political. Of course it's nice to plant oak trees, but will politicians then make the corresponding laws saying that more must be planted? How can we really achieve anything political with art?

BEUYS: Naturally it isn't done by this or that person with his or her limited means planting 7000 oak trees. What we need to do with this action and this stone as a symbolic act and this living creature, the tree, is connect the proper conceptual pictures. These conceptual pictures are what we're discussing now: that such necessary economic laws of the type we're demanding have to exist, laws that would be in a position to transform the emergency situation humanity finds itself in now into a better situation. . . . Here once again the oak turns up as a kind of nomadic, decentralized architecture, roaming through humanity and traveling the path of these new vital questions and ideas: but certainly not to put up these or those monuments in a merely aesthetic sense, instead to put the need for new economic concepts at the center of our thought. . . .

AUDIENCE: So why in Kassel?

BEUYS: It should happen first in an area where technology is very highly developed, somewhere from which the main damage is being spread around the world—so that we can start so to speak from the interface where consciousness has to be transformed and work back toward the regions where this reforestation is much more important. . . .

It's just a place from which things can spread internationally! I mean, surely you see the effectiveness of originating this kind of worldwide business and worldwide understanding of consciousness at a point where, with relatively simple means (7000 oaks are expensive, yes, but still they're a fairly simple means) something like this can be put into the world. . . . [*Beuys holds up for all to see the "Circular" published by the FIU and Dia Art Foundation, which is*

a kind of invitation to donate money] There'll be a copy in every room![2] That makes sixteen hundred hotels all over the world—from the Middle East to Australia, North America, South America—with at least three hundred rooms each, an immense propagation of an idea like this! . . .

We think politics must be replaced with an organizational concept, because all the questions of life—the organization of the global economic system too—are just questions of proper *forms*. So once you're conscious of this gigantic social artwork, once you've grasped new ways of structuring society, you'll be rid of those questionable concepts like "politics" and "politicians," and you'll be able to consider all people, in the most various businesses and undertakings, much more as just that: *human beings!*

1 Joseph Beuys and Bernhard Blume, "Conversation on Trees," April 24, 1982, at Galerie Magers, Bonn, West Germany, at the gallery's tenth anniversary celebration. The original German was transcribed from an audio recording by Johannes Stüttgen.
2 The artist is referring here to Holiday Inn hotel rooms. Viewing the international franchise as an ideal platform for spreading information across the globe, Beuys intended to team up with the hotel chain to distribute the *7000 Oaks* brochure in all sixteen hundred of its hotels around the world at that time.

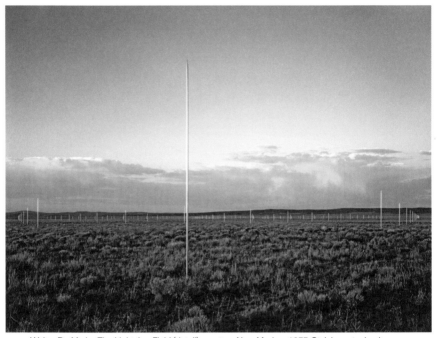

Walter De Maria, *The Lightning Field* (detail), western New Mexico, 1977. Stainless-steel poles, 400 parts: one mile by one kilometer. Dia Art Foundation

Walter De Maria

The Lightning Field, 1977
Western New Mexico

The New York Earth Room, 1977
141 Wooster Street
New York, New York

The Vertical Earth Kilometer, 1977
Friedrichsplatz Park
Kassel, Germany

The Broken Kilometer, 1979
393 West Broadway
New York, New York

Between 1977 and 1979 and with Dia Art Foundation's support, Walter De Maria realized four expansive sculptural installations in the United States and Europe, all of which challenged the notion of the work of art as a singular object. *The Lightning Field* (1977), *The New York Earth Room* (1977), *The Vertical Earth Kilometer* (1977), and *The Broken Kilometer* (1979) range from the environmentally immersive—*The Lightning Field*—to the nearly imperceptible—*The Vertical Earth Kilometer*—and are each monumental in their own right. Among the largest projects De Maria conceived, his four permanent Dia sites address abiding concerns of his practice. Together they explore how units of measurement are used to structure one's experience of the lived environment, the limits of visual perception, and the compelling lure of the invisible in the modern world.

Born in 1935 in Albany, California, De Maria studied history and art at the University of California, Berkeley. In 1960 he moved to New York City, where he lived and worked until he passed away in 2013. De Maria's early practice from the 1960s included performance and writing as well as sculptural and conceptual works that helped define such emerging movements as Fluxus, Minimalism, and Conceptual art. A pioneering figure of Land art,

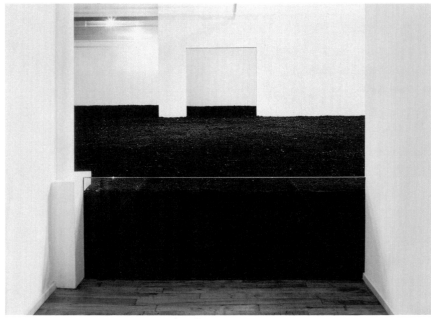

De Maria, *The New York Earth Room* (detail), 1977. Earth, peat, and bark, dimensions variable. Dia Art Foundation. Installation view, 141 Wooster Street, New York

he began making large, site-specific interventions in the western United States in 1968. Also a talented percussionist who performed with many other musicians, De Maria was briefly the drummer for the Primitives, a band that later evolved into the Velvet Underground.

Questions of weight and volume are integral to the formal and conceptual operations of *The New York Earth Room*. Similarly, *The Lightning Field*, *The Vertical Earth Kilometer*, and *The Broken Kilometer* all take basic ideas about length and distance as points of departure. *The New York Earth Room* is the third iteration of a project De Maria first realized in 1968 for Galerie Heiner Friedrich, Munich, West Germany. There the artist presented *50 M³ (1,600 Cubic Feet) Level Dirt/The Land Show: Pure Dirt/Pure Earth/Pure Land* (1968), an early gesture tied to the development of American Land art in which a material foundation of the exterior world—earth—was transposed into the white cube. The artist packed the gallery's three rooms with loose soil to an even depth, arresting its normal operations and shifting the viewer's attention from any sense of a discrete object to the substance's sheer volumetric occupation of space. The second iteration of *The Earth Room*, as the work came to be known, was installed in 1974 at the Hessisches Landesmuseum, Darmstadt, West Germany. In 1977 Friedrich invited De Maria to restage it for his New York gallery on the first floor of 141 Wooster Street. Compelled by how the work's formal simplicity engenders such a commanding physical presence, Friedrich and his partners at Dia, Fariha Friedrich and Helen Winkler Fosdick, in close consultation with the artist, determined that the work should remain on permanent view as a Dia site, as it has since its installation.

While De Maria was transforming Friedrich's gallery into *The New York Earth Room*, he was simultaneously developing *The Lightning Field*. Located in a remote area of western New Mexico, this permanent installation consists of four hundred polished steel rods placed in a grid one mile long by one kilometer wide. The artist first used the material in the mid-1960s in a series of small, geometric sculptures. Highly polished metals were subsequently

De Maria, *The Vertical Earth Kilometer* (detail), Friedrichsplatz Park, Kassel, Germany, 1979. Brass, 3280 feet, 10⅜ inches × 2 inches × 2 inches (1 km × 5 cm × 5 cm). Dia Art Foundation

featured in several of his most recognizable works. At *The Lightning Field*, the vertical poles vary in height to compensate for the earth's undulating surface, creating a level plane that could support a plate of glass.

The Lightning Field juxtaposes imperial and metric standards against the vast expanse of the American desert. Within this context, the hard edges of these empirical systems of observation dissolve against the seemingly boundless expanse of wide-open space. Moreover, *The Lightning Field* requires both movement and time to be fully experienced. In addition to the physical terrain that the project occupies, *The Lightning Field* is animated by changing light conditions, which cause the poles to come in and out of focus within the landscape throughout the day. Accordingly, De Maria determined that visitors need a full day at the site, and he arranged for the refurbishment of a historic homestead cabin where up to six people at a time can spend the night. This enormous undertaking required Winkler Fosdick and her husband, Robert Fosdick, to relocate to New Mexico for several years to help oversee the logistics of moving and renovating the cabin and installing the poles according to De Maria's precise instructions. A dedicated team of local caretakers continues to keep De Maria's vision for the site alive.

Like *The Lightning Field*, *The Vertical Earth Kilometer* and *The Broken Kilometer* both subversively deploy standard measurements to address the limits of visual perception, demonstrating the ways in which an aesthetic experience can exceed the supposedly quantifiable. With Dia's financial support, De Maria developed *The Vertical Earth Kilometer* in response to an invitation to participate in the international exhibition Documenta in Kassel, West Germany.[1] With the support of the city of Kassel, the work was ultimately designated as a permanent installation. A one-kilometer-long, polished-brass rod was buried vertically into Friedrichsplatz Park, leaving only the flat circumference of one end visible. It took seventy-nine days to drill the shaft, which passes through six geological layers. Notably, the work renders abstract a sense of distance and depth, which must be imagined from the flat tip of the pole.

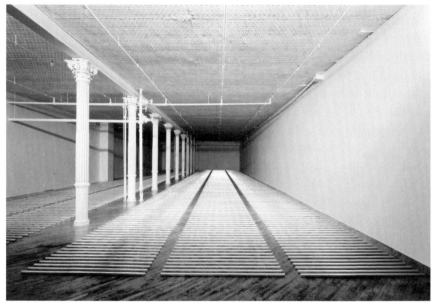

De Maria, *The Broken Kilometer* (detail), 1979. Brass, 500 parts: 2 × 78¾ × 2 inches (5 × 200 × 5 cm) each. Dia Art Foundation. Installation view, 393 West Broadway, New York

The companion piece to *The Vertical Earth Kilometer*, *The Broken Kilometer* consists of a nearly identical brass rod that has been divided into five hundred two-meter-long units. De Maria arranged these pieces in five parallel rows on the floor of 393 West Broadway in New York so that they appear evenly dispersed throughout the room. As with *The New York Earth Room*, this space was initially part of Friedrich's stable of galleries, and Dia's founders converted it into a permanent site once De Maria's work was installed in 1979. In *The Broken Kilometer* the artist deployed numerical sequencing as a compositional principle to achieve a semblance of regularity. The rows are spaced progressively farther apart, at increasing five-millimeter intervals, and the rods are elevated in height as they recede toward the back of the gallery. The appearance of a rational grid—the basis of cartographic logic—is thus an optical illusion created by the spacing of the brass rods. Like *The Lightning Field*, *The Broken Kilometer* measures the visual effects of both space and time in its own way. De Maria selected brass in part because the material oxidizes as it ages, darkening the metal and effectively accumulating time on its surface as years pass. However, the rods are polished every few years, resetting this temporal cycle so that viewers may see the process anew.

1 As George Baker and Christian Philipp Müller have written, it is notable that this project, which required extensive earth drilling, rehearsed the mechanics of mineral extraction that provided the source of wealth for the de Menil family and by extension Dia. See George Baker and Christian Philipp Müller, "A Balancing Act," *October*, no. 82 (Autumn 1997), p. 106. This aspect of Land art patronage remains largely underexamined.

FURTHER READING

Atkins, Katherine, and Kelly Kivland, eds. *Artists on Walter De Maria.* New York: Dia Art Foundation, 2017.

Hoban, Stephen, Alexis Lowry, and Jessica Morgan, eds. *Walter De Maria: The Lightning Field.* New York: Dia Art Foundation, 2017.

McFadden, Jane. *Walter De Maria: Meaningless Work.* London: Reaktion Books, 2016.

Wallis, Brian. "Walter De Maria's *The Broken Kilometer.*" *Arts Magazine* 54, no. 6 (February 1980), pp. 88–89.

Walter De Maria
The Lightning Field: *Some Facts, Notes, Data, Information, Statistics and Statements* (1980)

The Lightning Field is a permanent work.

The land is not the setting for the work but a part of the work.

The work is located in West Central New Mexico.
The states of California, Nevada, Utah, Arizona and Texas were searched by truck over a five-year period before the location in New Mexico was selected. Desirable qualities of the location included flatness, high lightning activity and isolation.
The region is located 7,200 feet above sea level.
The Lightning Field is 11½ miles east of the Continental Divide.
The earliest manifestation of land art was represented in the drawings and plans for the *Mile-Long Parallel Walls in the Desert*, 1961–1963.
The Lightning Field began in the form of a note, following the completion of *The Bed of Spikes* in 1969. The sculpture was completed in its physical form on November 1, 1977.
The work was commissioned and is maintained by the Dia Art Foundation, New York.

In July, 1974, a small *Lightning Field* was constructed. This served as the prototype for the 1977 *Lightning Field*. It had 35 stainless steel poles with pointed tips, each 18 feet tall and 200 feet apart, arranged in a five-row by seven-row grid. It was located in Northern Arizona. The land was loaned by Mr. and Mrs. Burton Tremaine. The work now is in the collection of Virginia Dwan. It remained in place from 1974 through 1976 and is presently dismantled, prior to an installation in a new location.

The sum of the facts does not constitute the work or determine its esthetics.

The Lightning Field measures one mile by one kilometer and six meters (5,280 feet by 3,300 feet).
There are 400 highly polished stainless steel poles with solid, pointed tips.
The poles are arranged in a rectangular grid array (16 to the width, 25 to the length) and are spaced 220 feet apart.
A simple walk around the perimeter of the poles takes approximately two hours.

The primary experience takes place within *The Lightning Field*.

Each mile-long row contains 25 poles and runs east-west.

Each kilometer-long row contains 16 poles and runs north-south.

Because the sky-ground relationship is central to the work, viewing *The Lightning Field* from the air is of no value.

Part of the essential content of the work is the ratio of people to the space: a small number of people to a large amount of space.

Installation was carried out from June through October, 1977.

The principal associates in construction, Robert Fosdick and Helen Winkler, have worked with the sculpture continuously for the last three years.

An aerial survey, combined with computer analysis, determined the positioning of the rectangular grid and the elevation of the terrain.

A land survey determined four elevation points surrounding each pole position to insure the perfect placement and exact height of each element.

It took five months to complete both the aerial and the land surveys.

Each measurement relevant to foundation position, installation procedure and pole alignment was triple-checked for accuracy.

The poles' concrete foundations, set one foot below the surface of the land, are three feet deep and one foot in diameter.

Engineering studies indicated that these foundations will hold poles to a vertical position in winds of up to 110 miles per hour.

Heavy carbon steel pipes extend from the foundation cement and rise through the lightning poles to give extra strength.

The poles were constructed of type 304 stainless steel tubing with an outside diameter of two inches.

Each pole was cut, within an accuracy of ⅟₁₀₀ of an inch, to its own individual length.

The average pole height is 20 feet 7½ inches.

The shortest pole height is 15 feet.

The tallest pole height is 26 feet 9 inches.

The solid, stainless steel tips were turned to match an arc having a radius of six feet. The tips were welded to the poles, then ground and polished, creating a continuous unit. The total weight of the steel used is approximately 38,000 pounds. All poles are parallel, and the spaces between them are accurate to within ½₅ of an inch. Diagonal distance between any two contiguous poles is 311 feet. If laid end to end the poles would stretch over one and one-half miles (8,240 feet). The plane of the tips would evenly support an imaginary sheet of glass.

During the mid-portion of the day 70 to 90 percent of the poles become virtually invisible due to the high angle of the sun.

It is intended that the work be viewed alone, or in the company of a very small number of people, over at least a 24-hour period.

The original log cabin located 200 yards beyond the mid-point of the

northern most row has been restored to accommodate visitors' needs.
A permanent caretaker and administrator will reside near the location
for continuous maintenance, protection and assistance.
A visit may be reserved only through written correspondence.
The cabin serves as a shelter during extreme weather conditions or storms.
The climate is semiarid; eleven inches of rain is the yearly average.
Sometimes in winter, *The Lightning Field* is seen in light snow.
Occasionally in spring, 30- to 50-mile-an-hour winds blow steadily
for days.
The light is as important as the lightning.
The period of primary lightning activity is from late May through
early September.
There are approximately 60 days per year when thunder and lightning
activity can be witnessed from *The Lightning Field*.

The invisible is real.

The observed ratio of lightning storms which pass over the sculpture
has been approximately 3 per 30 days during the lightning season.
Only after a lightning strike has advanced to an area of about 200 feet
above *The Lightning Field* can it sense the poles.
Several distinct thunderstorms can be observed at one time from
The Lightning Field.
Traditional grounding cable and grounding rod protect the foundations by
diverting lightning current into the earth.
Lightning strikes have not been observed to jump or arc from pole to pole.
Lightning strikes have done no perceptible damage to the poles.
On very rare occasions when there is a strong electrical current in the air, a
glow known as "St. Elmo's Fire" may be emitted from the tips of the poles.
Photography of lightning in the daytime was made possible by the use of
camera triggering devices newly developed by Dr. Richard Orville, Dr.
Bernard Vonnegut and Robert Zeh, of the State University of New York
at Albany.
Photography of *The Lightning Field* required the use of medium- and
large-format cameras.
No photograph, group of photographs or other recorded images can
completely represent *The Lightning Field*.

Isolation is the essence of Land Art.

Nancy Holt, *Sun Tunnels*, Great Basin Desert, Box Elder County, Utah, 1973–76. Concrete, steel, and earth, four parts: 18 feet, 1 inch × 9 feet, 3 inches diameter (5.5 × 2.8 m) each; 9 feet, 3 inches × 68 feet, 6 inches × 53 feet (2.8 × 20.9 × 16.2 m) overall. Dia Art Foundation with support from Holt/Smithson Foundation

Nancy Holt, *Sun Tunnels*, 1973–76
Great Basin Desert
Box Elder County, Utah

Nancy Holt's *Sun Tunnels* (1973–76) is situated within a forty-acre plot in the Great Basin Desert in northeastern Utah. Composed of four concrete cylinders that are approximately eighteen feet long and nine feet in diameter, *Sun Tunnels* is arranged on the desert floor in an "x" pattern. During the summer and winter solstices, the four tunnels align with the angles of the rising and setting sun. Each tunnel has a different configuration of holes, corresponding to stars in the constellations Capricorn, Columba, Draco, and Perseus.

Holt was born in 1938 in Worcester, Massachusetts, and raised in New Jersey. After graduating with a degree in biology in 1960 from Tufts University, Medford, Massachusetts, she moved to New York City and worked successively as an assistant literary editor at *Harper's Bazaar*, a teacher at the Downtown Community School, and a researcher at the Lederle Labs in Pearl River, New York. During this time, Holt began composing concrete poetry as well as creating video, sound, and photographic work that aligned her interests in the nuances of observation and the particularities of site. By the early 1970s, her work became increasingly concerned with the complexities of perception, specifically the effects of light and focus on spatial and temporal conceptions. In 1971 she initiated her Locators, a series in which vertical steel-rod sculptures, supporting small pipes through which a viewer could look, give focus to discrete points of view. With the Locators, she felt that she had discovered the "key that led to [her] later sculpture," emphasizing the material properties of perception.[1] In a notebook entry dated October 1971, Holt elaborated on this breakthrough: "Bringing art back to the eye—treatment in depth. Changes made in depth rather than on a flat plane. Near and far interrelate in a new way. . . . Perception dealt with directly—no illusion."[2]

Holt first visited the western United States in 1968. Her engagement with the landscape is manifest in her series of photographs

Western Graveyards (1968) and the film *Mono Lake* (1968/2004), a work made with artists Michael Heizer and Robert Smithson, her husband. Holt's interest in the West as both concept and terrain is evident in her first site-specific environmental work, *Missoula Ranch Locators: Vision Encompassed* (1972), for which she placed a group of her Locator sculptures in a large field in Montana. Also during this period, she developed the room-sized installations *Holes of Light* (1973) and *Mirrors of Light I* (1974), which explore properties of light such as reflection and refraction. Holt's experiments with artificial light led her to work with natural light in the landscape and, eventually, conceive *Sun Tunnels*.

"The idea for *Sun Tunnels* became clearer to me while I was in the desert watching the sun rising and setting, keeping the time of the earth. *Sun Tunnels* can exist only in that particular place— the work evolved out of its site," said Holt.[3] She began working on *Sun Tunnels* in 1973 while in Amarillo, Texas. As her ideas developed, Holt searched for a location in Arizona, New Mexico, and Utah. She was specifically looking for a "flat desert ringed by low mountains," which she found in Utah.[4] The following year, Holt purchased forty acres of land in the Great Basin Desert. During the development of what would become *Sun Tunnels*, she worked with an astrophysicist and astronomer to consult on the dynamics of the work, as well as several local contractors on its construction. It was completed in 1976.

Sun Tunnels functions like an enormous sundial: its small holes allow the sun to cast shadows tracing the earth's rotation inside the tunnels, which provide a visible yet impermanent record of the passing of each day and year. The concrete tubes act as view-finders that frame precise images. Finding the empty space of the desert disorienting, Holt devised *Sun Tunnels* as a means for directing vision within the vast landscape. Moreover, at approxi-mately nine feet in diameter, the cylinders are large enough to circumscribe even the tallest person. The ability to place oneself in the work was important to the artist, who wanted to "bring the vast space of the desert back to human scale."[5]

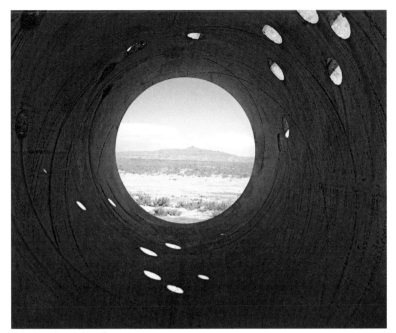

Holt, *Sun Tunnels* (detail)

Holt's film *Sun Tunnels* (1978) documents the immense scope of realizing the artwork, from a long shot of the open desert, to the casting of the concrete tunnels punctured with constellation holes, to the positioning of the work in the landscape. The final sequences of the film capture the setting sun during the summer solstice, highlighting the performance of light and shadow patterns in the final installation.

Drawing on the most fundamental tools for mapping—the sun and stars—Holt's project locates itself and the viewer within the barren expanse of the region. Defined by both the landscape and the larger cosmos, *Sun Tunnels* sculpts the sun's light through the interplay of land and sky, and celestial shifts from day to night. In 2018 Dia Art Foundation acquired *Sun Tunnels* with support from the Holt/Smithson Foundation.

1 Nancy Holt, quoted in James Meyer, "Interview with Nancy Holt," in *Nancy Holt: Sightlines*, ed. Alena Williams (Berkeley: University of California Press, 2011), p. 225.
2 Nancy Holt, "Getting Out of Sight" (October 1971), in *Nancy Holt: Locators* (London: Parafin, 2015), p. 51.
3 Nancy Holt, "Sun Tunnels," in this volume, p. 74.
4 Ibid., p. 67.
5 Ibid., p. 71.

FURTHER READING

Donnelly, Mick, and Nancy Holt. "Nancy Holt Interviewed by Mick Donnelly." *Circa Art Magazine*, no. 11 (July–August 1983), pp. 4–10.

Lippard, Lucy R. *Overlay: Contemporary Art and the Art of Prehistory.* New York: New Press, 1983.

Williams, Alena, ed. *Nancy Holt: Sightlines.* Berkeley: University of California Press, 2011.

PARTNERSHIPS

Dia partners with the Center for Land Use Interpretation, Holt/Smithson Foundation, and the Utah Museum of Fine Arts at the University of Utah on initiatives that further advocate for the care and understanding of *Sun Tunnels* and its legacy.

Center for Land Use Interpretation, Wendover, Utah

The Center for Land Use Interpretation is a research and education organization interested in understanding the nature and extent of human interaction with the surface of the earth. For more information, visit clui.org.

Holt/Smithson Foundation

Holt/Smithson Foundation exists to continue the creative and investigative spirit of the artists Nancy Holt and Robert Smithson. For more information, visit holtsmithsonfoundation.org.

Utah Museum of Fine Arts, University of Utah, Salt Lake City

The Utah Museum of Fine Arts ensures that the cultural reputation of *Sun Tunnels* is upheld locally and promotes the exceptional significance of the artwork within Utah. For more information, visit umfa.utah.edu.

Nancy Holt
Sun Tunnels (1977)

Sun Tunnels *(1973–76) is built on 40 acres which I bought in 1974 specifically as a site for the work. The land is in the Great Basin Desert in northwestern Utah, about 4 miles southeast of Lucin (pop. ten) and 9 miles east of the Nevada border.*

Sun Tunnels *marks the yearly extreme positions of the sun on the horizon—the tunnels being aligned with the angles of the rising and setting of the sun on the days of the solstices, around June 21st and December 21st. On those days the sun is centered through the tunnels, and is nearly centered for about 10 days before and after the solstices.*

The four concrete tunnels are laid out on the desert in an open X configuration 86 ft. long on the diagonal. Each tunnel is 18 ft. long, and has an outside diameter of 9 ft. 2½ in. and an inside diameter of 8 ft. with a wall thickness of 7¼ in. A rectangle drawn around the outside of the tunnels would measure 68½ feet x 53 ft.

Cut through the wall in the upper half of each tunnel are holes of four different sizes—7, 8, 9, and 10 in. in diameter. Each tunnel has a different configuration of holes corresponding to stars in four different constellations—Draco, Perseus, Columba, and Capricorn. The sizes of the holes vary relative to the magnitude of the stars to which they correspond. During the day, the sun shines through the holes, casting a changing pattern of pointed ellipses and circles of light on the bottom half of each tunnel. On nights when the moon is more than a quarter full, moonlight shines through the holes casting its own paler pattern. The shapes and positions of the cast light differ from hour to hour, day to day, and season to season, relative to the positions of the sun and moon in the sky.

Each tunnel weighs 22 tons and rests on a buried concrete foundation. Due to the density, shape, and thickness of the concrete, the temperature is 15 to 20 degrees cooler inside the tunnels in the heat of day. There is also a considerable echo inside the tunnels.

—N.H.

"Sun Tunnels" by Nancy Holt was originally published in *Artforum* 15, no. 8 (April 1977), pp. 32–37. © Holt/Smithson Foundation/Licensed by VAGA at Artists Rights Society (ARS), New York and Artforum, April 1977

In 1974 I looked for the right site for *Sun Tunnels* in New Mexico, Arizona, and Utah. What I needed was flat desert ringed by low mountains. It was hard finding land which was both for sale and easy to get to by car. The state and federal governments own about two-thirds of the land, the rest is owned mainly by railroads and large ranches, and is usually sold in one-square-mile sections. Fortunately, the part of the valley I finally chose for *Sun Tunnels* had been divided up into smaller sections, and several of these were for sale. I bought forty acres, a quarter of a mile square.

My land is in a large, flat valley with very little vegetation—it's land worn down by Lake Bonneville, an ancient lake that gradually receded over thousands of years. The Great Salt Lake is what remains of the original lake now, but it's just a puddle by comparison. From my site you can see mountains with lines on them where the old lake bit into the rock as it was going down. The mirages are extraordinary: you can see whole mountains hovering over the earth, reflected upside down in the heat. The feeling of timelessness is overwhelming.

> An interminable string of warped, arid mountains with broad valleys swung between them, a few waterholes, a few springs, a few oasis towns and a few dry towns dependent for water on barrels and horsepower, a few little valleys where irrigation is possible . . . a desert more vegetationless, more indubitably hot and dry, and more terrible than any desert in North America except possibly Death Valley. . . . Even the Mormons could do little with it. They settled its few watered valleys and let the rest of it alone.
> —Wallace Stegner in *Mormon Country: The Land Nobody Wanted*

In the surrounding area are old trails, crystal caves, disused turquoise, copper, and tungsten mines, old oil wells and windmills, hidden springs, and ancient caves. A nearby cave, coated with centuries of charcoal and grease, is filled with at least 10 feet of residue—mostly dirt, bones, and artifacts. Out there a "lifetime" seems very minute. After camping alone in the desert awhile, I had a strong sense that I was linked through thousands of years of human time with the people who had lived in the caves around there for so long. I was sharing the same landscape with them. From the site, they would have seen the sun rising and setting over the same mountains and ridges.

The closest settlement is 4 miles away in Lucin, Utah. It's a village of 10 people; 9 are retired and one works for the railroad. Until the demise of the railroad, Lucin and Tacoma (10 miles west) were thriving towns of a few hundred people, with hotels, cafes, barber shops, saloons. Tacoma is

completely leveled now. Except for a sign, there is no way of telling that a town had once been there. Lucin has only one of its old buildings left standing. The next closest town, Montello, Nevada (pop. 60), 22 miles west, went through a similar process, but is more intact: even a few of the original sheds, made of interlocking railroad ties covered with sod roofs, still exist.

> Dawn points, and another day
> Prepares for heat and silence.
> —T. S. Eliot, *The Waste Land*

The idea for *Sun Tunnels* came to me while I was in Amarillo, Texas, in 1973, but it wasn't until the next year that I bought land for the work. Then in August of 1975 I went back to Utah and began working. I didn't know anyone there, and was totally outside any art-world structure. I was one individual contacting other individuals. But by the time *Sun Tunnels* was finished, I had spent one year in Utah and had worked with 2 engineers, 1 astrophysicist, 1 astronomer, 1 surveyor and his assistant, 1 road grader, 2 dump truck operators, 1 carpenter, 3 ditch diggers, 1 concrete mixing truck operator, 1 concrete foreman, 10 concrete pipe company workers, 2 core-drillers, 4 truck drivers, 1 crane operator, 1 rigger, 2 cameramen, 2 soundmen, 1 helicopter pilot, and 4 photography lab workers.

In making the arrangements and contracting out the work, I became more extended into the world than I've ever been before. It was hard involving so many people in making my art. Since my two grants covered only one-third the total cost, and I was financing the other two-thirds with my own money, I had to hustle quite a bit to keep down the cost and get special consideration. Making business deals doesn't come easy to me; it was often very exasperating. I don't have any romantic notions about testing the edges of the world that way. It's just a necessity. It doesn't lead to anything except the work.

I went out West for the first time in 1968 with Robert Smithson and Michael Heizer.[1] As soon as I got to the desert, I connected with the place. Before that, the only other place that I had felt in touch with in the same way was the Pine Barrens in southern New Jersey,[2] which only begins to approach that kind of Western spaciousness.

I went back West for a few months every year. In 1969 I began a series of "Buried Poems,"[3] using some desert sites. Then in 1972 I made *Missoula*

Ranch Locators[4] in Montana in a very different kind of Western landscape—very expansive, but greener and more "scenic" than the desert. The site is right for the work; different things can be seen through each of the eight *Locators*—a mountain, a tree, a flat plain, a ranch house, etc. Through the work, the place is seen in a different way. The work becomes a human focal point, and in that respect it brings the vast landscape back to human proportion and makes the viewer the center of things. In both works I used a natural ordering; *Missoula Ranch Locators* is positioned on the points of the compass, *Sun Tunnels* on the angles of the solstices at the latitude of the site.

When I was making projected light works in New York, the idea of working with the actual projected light of the sun began to intrigue me. I put cut-outs in my window and models on my roof in New York, so I could watch the light and shadow change hour by hour, day by day. In Utah I made drawings and worked with scale models and large hoops in the desert, trying out different lengths, diameters, and placements, and doing photographic studies of the changes in light and shadow. I consulted with an astrophysicist[5] at the University of Utah about the angles of the solstices at the latitude of my land. Because the land had irregular contours, and the earth was not a perfect sphere, we had to calculate the height of the distant mountains and ridges and, using a computer, readjust the solstice angles from this date. The angles we arrived at formed an "X," which worked as a configuration for the tunnels. Using a helioscope set for the latitude of the site, it was possible to study the changes in light and shadow in my model for every hour during every day of the year.

"Time" is not just a mental concept or a mathematical abstraction in the desert. The rocks in the distance are ageless; they have been deposited in layers over hundreds of thousands of years. "Time" takes on a physical presence. Only 10 miles south of *Sun Tunnels* are the Bonneville Salt Flats, one of the few areas in the world where you can actually see the curvature of the earth. Being part of that kind of landscape, and walking on earth that has surely never been walked on before, evokes a sense of being on this planet, rotating in space, in universal time.

By marking the yearly extreme positions of the sun, *Sun Tunnels* indicates the "cyclical time" of the solar year. The center of the work becomes the center of the world. The changing pattern of light from our "sun-star"

marks the days and hours as it passes through the tunnel's "star-holes." The positioning of the work is also based on star-study: the surveyor and I were only able to find True North by taking our bearings on the North Star—Polaris—as it ovals around the North Pole because of the earth's movement.

I wanted to bring the vast space of the desert back to human scale. I had no desire to make a megalithic monument. The panoramic view of the landscape is too overwhelming to take in without visual reference points. The view blurs out rather than sharpens. Through the tunnels, parts of the landscape are framed and come into focus. I chose the diameter, length, and distance between the tunnels based on the proportions of what could be seen of the sky and land, and how long the sun could be seen rising and setting on the solstices.

In the desert, scale is hard to discern from a distance. Mountains that are 5 or 10 miles away look deceptively close. When *Sun Tunnels* is seen from 4 miles away, it seems very large. Closer in, a mile or so away, the relational balance changes and is hard to read. The work is seen from several angles on the road in; at times two of the tunnels line up exactly head on and seem to disappear. Seen from a side angle, the two tunnels in front can totally overlap and cancel out the ones in the back.

From the center of the work, the tunnels extend the viewer visually into the landscape, opening up the perceived space. But once inside the tunnels, the work encloses—surrounds—and there is a framing of the landscape through the ends of the tunnels and through the holes.

The color and substance of the tunnels is the same as the land that they are a part of, and the inner matter of the concrete—the solidified sand and stone—can be seen on the insides of the holes, where the "core-drill" cut through and exposed it. In that kind of space the work had to have a substantial thickness and weight, which was only possible with concrete. The rims are wide enough to frame the space from long distances, and the weight (22 tons per tunnel) gives the work a feeling of permanence.

> Only the sunlight holds things together. Noon is the crucial hour; the desert reveals itself nakedly and cruelly, with no meaning but its own existence.
>
> —Edward Abbey, *Desert Solitaire*

In the glare of the desert sunlight, I want to turn away from the sun, rather than contemplate it. When the sunlight is all around me like that, I only become conscious of it when it is edged by shadow. The sunlight pours in wherever there are holes in the tunnels. Because of the 7¼-inch thickness of the holes, the shape of the light that reaches the bottom of the tunnels is usually a pointed ellipse, but there are times when the sun is directly over a hole and a perfect circle is cast. Day is turned into night, and an inversion of the sky takes place: stars are cast down to Earth, spots of warmth in cool tunnels.

Moonlike crescents of light form inside the rims of the tunnels. They elongate in the early and late hours of the day, and disappear altogether when the tunnels are in full shadow inside, which occurs at a different time on one diagonal of the "X" than it does on the other. (Around the summer solstice this happens about 12:30 and 3:30.) On days when the clouds come and go, there is a dimming, a darkening, and then a brightening of the areas of light.

When the sun beats down the site, the heat waves seem to make the earth dissolve, and the tunnels appear to lose their substance—they float like the mirages in the distance. Around the time of the solstices, when the sun rises and sets through the tunnels, it glows bright orange on the tunnel walls.

> When the white-hot sun was sinking
> To the blue edge of the mountain,
> The watchers saw the whiteness turn
> To red along the rim.
> Saw the redness deepen, till the sun
> Like a huge bowl filled with fire
> Red and glowing, seemed to rest upon the world.
> —Navajo Indian Poem, trans. Eugenia Faunce Wetherill

> The sun is nothing out of the ordinary in the universal scheme of things: merely one star among thousands of millions, and not even a particularly large or bright one.
> —J. B. Sidgwick, *Introducing Astronomy*

At night, even a quarter moon can cast a pattern of light. The moonlight shines through the holes in different positions and with a different intensity than the sunlight does. In the moonlight the tunnels seem to glow from within their own substance, the rims of the tunnels forming crescents in the night. As you move through the tunnels, the moon and stars and planets can be lined up and framed through each hole. Looking up through the holes on a bright night is like seeing the circles of light during the day, only inverted.

The Moon was formed billions of years ago. But no one is sure just how.
Space was full of dust and rocks in those days, and these came together to
form the Earth. Perhaps when the Earth was first formed, part of it broke
loose and became the Moon.

—Isaac Asimov, *The Moon*

Thus he conceived his voyaging to be
An up and down between two elements,
A fluctuating between sun and moon,
A sally into gold and crimson forms.

—Wallace Stevens, "The Comedian as the Letter C"

In choosing the constellation for the holes, I wanted only those with stars of
several different magnitudes, so that I could have holes of different diameters.
Depending on which of the 12 astronomical charts I consulted, the number
and positions of the stars in the constellations varied, increasing my options
considerably. Each constellation had also to have enough stars, and to
encompass the top half of a tunnel with some holes at eye level on each side,
so that the viewer could look through the eye-level holes from the outside
and see through the holes on the other side of the tunnel. With those criteria
there were only a few constellations that I could use, and from them I chose
Draco, Perseus, Columba, and Capricorn. Together, they encompass the
globe—Columba is a Southern Hemisphere constellation which slips over
the edge of the horizon for a short time each year, but can't be seen because
of the dense atmosphere near the earth. Capricorn is visible in the fall and
early winter, and is entered by the sun at the winter solstice. Draco and
Perseus are always visible in the sky.

The work was constructed in several stages. From True North in the
center of the site, the surveyor and I staked out the solstice angles that
the astrophysicist had calculated. But before digging the first hole for the
foundations, I wanted actually to "see" a solstice. Delaying the work until
the end of December meant delaying the work until the spring, because the
ground would be frozen. In the interim before the winter solstice, I hired
a road gravelling crew and gravelled a ¾-mile road out to the site. On
December 22nd we watched the sunrise and sunset and the data checked out.

I worked with the engineers in designing the foundations, and began
getting estimates from contractors. It was difficult to find good workers who
would go 200 miles from Salt Lake City into the middle of the desert to

work. But by spring I had found some, and the holes were dug and the foundations poured. It took two weeks finally to convince the owner of the road construction company, 50 miles away in Oasis, Nevada, to send a concrete-mixing truck to my site. A few local people volunteered their help with this work and with the final installation.

I was in the pipe yard every day while the tunnels were being constructed.[6] I made templates to mark the hole positions on the inner and outer pipe forms, so that the steel that goes into the wall of the pipe—the re-bar cage—could be cut wherever there was going to be a hole. Steel rings were welded around the areas where the holes would be cut to increase the strength. The pipe form had to be blocked on one end to make the ends of the tunnels smooth, not recessed.

The core drilling was done with hollow, cylindrical drill heads ringed with diamonds. As a hole was cut, the edge of the drill head would slice through the wall, taking the core of concrete out with it as the drill was removed. When the core drilling was finished, I hired four large low-boy trucks to haul the tunnels, and a 60-ton crane, which went the 200 miles out to the site at 25 m.p.h., to lift them onto the foundations.

The local people and I differ on one point: if the land isn't too good for grazing, or if it doesn't have water, or minerals, or shade, or interesting vegetation, then they think it's not much good. They think it's very strange when I camp out at my site, although they say they're glad I found a use for that land. Many of the local people who came to my summer solstice camp-out had never been out in that valley before. So by putting *Sun Tunnels* in the middle of the desert, I have not put it in the middle of their regular surroundings. The work paradoxically makes available, or focuses on, a part of the environment that many local people wouldn't normally have seen.

The idea for *Sun Tunnels* became clearer to me while I was in the desert watching the sun rising and setting, keeping the time of the earth. *Sun Tunnels* can exist only in that particular place—the work evolved out of its site.

Words and photographs of the work are memory traces, not art. At best, they are inducements for people to go and see the actual work.

1 On that first trip West, Smithson and I collected rocks for his *Non-Sites*, while Heizer was making his initial works in the dry lake near Las Vegas. Together, the three of us made a film at Mono Lake, a salt lake in the California desert, and I did some still photography of the land.

2 In 1975 I made a thirty-two-minute, 16 mm, color and sound film, *Pine Barrens*, about that area.

3 Each "Buried Poem" was made for a specific person, who received a booklet containing maps, descriptions and/or history of the site, and detailed directions for retrieving the poem, which was buried in a vacuum container.

4 *Missoula Ranch Locators*, 1972, is 22 miles north of Missoula, Montana, on Route 10A-93 on the Waddell Ranch. Eight *Locators*, made of 2-inch diameter, galvanized steel pipe, welded in a T shape, their ends embedded in the ground, are placed on the points of the compass in a 40 ft. diameter circle. A viewer, looking through a pipe toward the center of the circle, sees the opposing *Locator* within the diameter of the circle of vision. Looking outward through the *Locators*, various aspects of the landscape are seen.

5 Les Fishbone, the astrophysicist, calculated the solstice angles to be 31.98° north and south of east and west. Robert Bliss, Dean of the School of Architecture at the University of Utah, allowed me to use their helioscope. Harold Stiles, a surveyor and engineer, did the readings of the sunrises and sunsets, and laid out the solstice angles at the site.

6 By spring the estimated cost of my pipes had doubled, because the pipe forms that I needed had to be shipped in from Los Angeles. So I decided to go to Los Angeles and meet with Jack McGill, the president of the U.S. Pipe Co., to see if I could interest him in subsidizing a work of art. The outcome was disappointing—they saw no value in getting involved with art; they did however reduce the cost of the pipes about 5 percent and their engineer approved the stability and strength of my design. I met with executives of two other large concrete pipe companies in the Los Angeles area with the same results, but only U.S. Pipe had a plant in Utah.

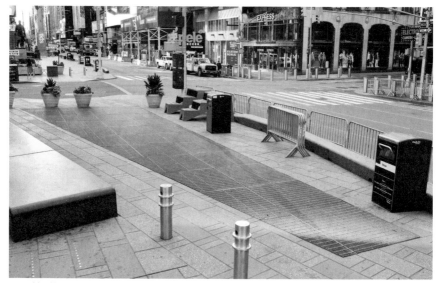

Max Neuhaus, *Times Square*, triangular pedestrian plaza at Broadway and 7th Avenue south of 46th Street, New York, 1997. Digital sound signal. Dia Art Foundation

Max Neuhaus, *Times Square*, 1977
Triangular pedestrian plaza at Broadway and 7th Avenue south of 46th Street
New York, New York

Max Neuhaus's *Times Square* (1977) sits beneath a triangular pedestrian plaza on Broadway between Forty-fifth and Forty-sixth Streets in New York City. A pedestrian walking through this heavily trafficked area can hear, emanating from below a grate in the street, a deep and slightly pulsating droning that changes in pitch, timbre, and tone with shifts in bodily position. Installed in 1977, shut off in 1992, and reactivated in 2002, *Times Square* is a key example of both Neuhaus's environmental work with sound and the broader postwar embrace of the medium in art. Today, under Dia Art Foundation's stewardship, it is audible twenty-four hours a day, seven days a week, an ongoing interlocutor with the city's mercurial topography.

Born in New York in 1939, Neuhaus began at age fourteen to develop his prodigious talents as a percussionist within the city's jazz scene. While training at the Manhattan School of Music, he encountered the work of experimental American composers John Cage, Morton Feldman, and Harry Partch, and later toured with pioneering European serial music composers Pierre Boulez and Karlheinz Stockhausen.

In 1968 Neuhaus left the music world for what he saw as the expanded possibilities of the visual arts. Like the works of such peers as Richard Serra and Gordon Matta-Clark, who also pushed the aesthetic boundaries of site, Neuhaus's early art of the mid-1960s explored the sonic contingencies of physical locations relayed through technological and media experimentation. For the four-day duration of *Fan Music* (1967), for example, Neuhaus amplified sounds from atop buildings on New York's Bowery using solar-powered cells behind rotating fan blades. The weather controlled the rotation of the blades and, by extension, the work's sonic intensity. The work inaugurated the artist's Place series, in which the physical realities of a site condition the

aesthetic experience. Neuhaus also engaged specific urban architectures, as in *Walkthrough* (1973–77), wherein a series of mobile clicks and pings could be heard in the arcade of the Jay Street–Borough Hall (now Jay Street–MetroTech) subway station in Brooklyn. As the artist succinctly described such works: "I use sound to change the way we perceive a space."[1]

For *Times Square*, Neuhaus again adapted New York's transit infrastructure for aural effect. The project took four years to realize—the artist began negotiations with the Metropolitan Transit Authority (MTA) and the city's largest energy company, Consolidated Edison (ConEd), in 1973. As the MTA would not collaborate with a private individual, Neuhaus founded the nonprofit Hybrid Energies for Acoustic Resources (HEAR) to facilitate production. To construct *Times Square*, he climbed into a ventilation shaft beneath a street grate and installed a loud-speaker and homemade electronic sound generators. The internal subway voltage proved too high to power the work, and ConEd refused to join an electrical connection to MTA property, forcing him to hire an independent maintenance company to improvise a line to a nearby streetlight. The end result, completed in September 1977, was a subterranean tone audible on the street, a sound Neuhaus later likened to an "after ring of large bells."[2] The artist refused any public signage so that *Times Square* would operate in total anonymity for the everyday pedestrian.

As Neuhaus's career shifted to European commissions, he could no longer adequately supervise the maintenance of *Times Square*. Powering the piece continued to be a problem, and in 1992 the work was disconnected. A decade later, as American critical attention returned to Neuhaus's oeuvre, *Times Square* was permanently revived through a collaboration with the artist, gallerist Christine Burgin, MTA Arts for Transit, Times Square Business Improvement District, various unaffiliated individuals, and Dia. In relaunching the project Neuhaus amplified its volume to account for the area's increased noise. Inspired by Neuhaus's interest in site specificity and durational sound, Dia later commis-sioned *Time Piece Beacon*, a permanent sound installation that was realized in 2005 at Dia Beacon in Beacon, New York.

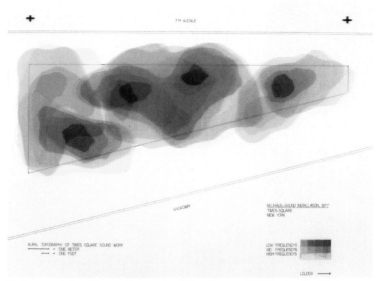

Neuhaus, rendering of the aural topography of *Times Square*, 1977. Courtesy the Estate of Max Neuhaus

Times Square refuses the total assimilation of art into everyday life that was endorsed by Neuhaus's contemporaries in Fluxus and related movements. Instead, the work addresses the nature of public experience. The artist described the sounds of his installations as "plausible" in a given location.[3] In the case of *Times Square*, the drone is only possibly part of the city's soundscape. The work invites passersby to reflect on what is customary to an urban environment and what is mutable. "I wanted a work that wouldn't need indoctrination," Neuhaus once stated. "The whole idea is that people discover it for themselves. They can't explain it. They take possession of it as their own discovery."[4]

1 Max Neuhaus, "Lecture at the Seibu Museum Tokyo," in *Max Neuhaus: Sound Works*, vol. 1, *Inscription* (Ostfildern, Germany: Cantz, 1994), p. 60.
2 Neuhaus's circumscription drawing.
3 Max Neuhaus, "Notes on Place and Moment," in *Sound Works*, p. 98.

4 Neuhaus, quoted in Sam Roberts, "Something Fresh Wafting up from a Times Square Grate: Art," *New York Times*, March 26, 2006, https://www.nytimes.com/2006/03/26/nyregion/somthing-fresh-wafting-up-from-a-times-square-grate-art.html.

FURTHER READING

Biserna, Elena. "Site-Specific Exhibition and Reexhibition Strategies: Max Neuhaus's Times Square." In *Preserving and Exhibiting Media Art: Challenges and Perspectives*, edited by Vinzenz Hediger, Barbara Le Maître, Julia Noordegraaf, and Cosetta G. Saba. Amsterdam: Amsterdam University Press, 2013, pp. 370–75.

Cooke, Lynne, and Karen Kelly, eds. *Max Neuhaus: Times Square, Time Piece Beacon*. New York: Dia Art Foundation, 2009.

Cox, Christoph. "Enduring Work: Max Neuhaus." *Artforum* 47, no. 9 (May 2009), pp. 49–52.

Neuhaus, Max. *Max Neuhaus: Sound Works*. Ostfildern, Germany: Cantz, 1994.

Tomkins, Calvin. "Hear." *New Yorker* (October 24, 1988), pp. 110–20.

Max Neuhaus
Times Square (1977)

The work is located on a pedestrian island: a triangle formed by the intersection of Broadway and Seventh Avenue, between Forty-Sixth and Forty-Fifth Streets, in New York City's Times Square.

The aural and visual environment is rich and complex. It includes large billboards, moving neon signs, office buildings, hotels, theaters, porno centers and electronic game emporiums. Its population is equally diverse, including tourists, theatregoers, commuters, pimps, shoppers, hucksters and office workers. Most people are in motion, passing through the square. The island, as it is the junction of several of the square's pathways, is sometimes crossed by a thousand or more people in an hour.

The work is an invisible unmarked block of sound on the north end of the island. Its sonority, a rich harmonic sound texture resembling the after ring of large bells, is an impossibility within its context. Many who pass through it, however, can dismiss it as an unusual machinery sound from below ground.

For those who find and accept the sound's impossibility though, the island becomes a different place, separate, but including its surroundings. These people, having no way of knowing that it has been deliberately made, usually claim the work as a place of their own discovering.

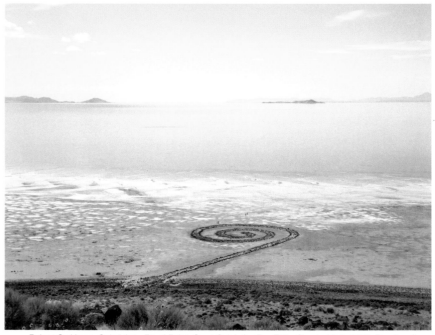

Robert Smithson, *Spiral Jetty*, Rozel Point, Great Salt Lake, Box Elder County, Utah, 1970. Basalt, salt crystals, earth, and water, approximately 1,500 feet long × 15 feet wide (457 × 4.5 m); approximately 328 × 492 feet (100 × 150 m) overall. Dia Art Foundation

Robert Smithson, *Spiral Jetty*, 1970
Rozel Point, Great Salt Lake,
Box Elder County, Utah

Robert Smithson's *Spiral Jetty* (1970) is located at the Rozel Point peninsula on the northeastern shore of the Great Salt Lake. With the assistance of a team operating dump trucks, a front loader, and a tractor, Smithson created the sculpture over three weeks in April 1970. The artist moved six thousand tons of black basalt and earth from the adjacent shore to form a coil measuring approximately 1,500 feet long and 15 feet wide, winding counter-clockwise into the lake. Through the generosity of the artist Nancy Holt, Smithson's widow, and the Estate of Robert Smithson, the artwork entered Dia Art Foundation's collection in 1999.

Smithson was born in 1938 in Passaic, New Jersey. Before realizing *Spiral Jetty*, Smithson had established a remarkably diverse practice. He began his career as a painter, and his first solo exhibition was in 1959, at Artist's Gallery, New York. In 1964 he began to produce what he considered his first mature works of writing and sculpture. In the mid-1960s he started to experiment with different media, including drawing, film, sculpture, writing, and eventually earthworks. Deeply engaged with geology, crystallography, and science in its popularized forms like encyclopedic collections, natural-history museums, and science-fiction cinema and literature, Smithson focused on processes of accumulation and displacement in order to reveal connections as well as contradictions in our visible world. His work increasingly revolved around the relationship between art and place, and his scientific inclinations enabled him to consider properties of the natural world in very specific ways. These investigations yielded his influential concepts of "site," in which an artwork is created at an outdoor location, and "nonsite," in which materials from the land are taken from a site to create an indoor earthwork. Smithson's *Leaning Mirror* (1969), for example, is a seminal nonsite that consists of two six-foot-square mirrors tilted at a precise angle and embedded in a mound of sand taken from the town of Heerlen, the Netherlands. In other instances, Smithson,

who died in 1973 in a plane crash near Amarillo, Texas, while creating the earthwork *Amarillo Ramp*, worked directly in the peripheral spaces that inspired him. Sometimes the results were fleeting documentations, as with the illustrated travel-essay "A Tour of the Monuments of Passaic, New Jersey" (1967); other times, they were permanent, large-scale sculptural interventions, as in the case of *Spiral Jetty*.

"I like landscapes that suggest prehistory," said Smithson.[1] The artist chose to create *Spiral Jetty* in the Great Salt Lake due in part to the lake's unusual physical qualities, including the reddish coloration of the water caused by bacteria and the crystallized salt deposits that form on the peninsula's black boulders of hardened lava—scattered remnants of the now-extinct volcanos in the area. The fractured rocky landscape and fluctuating water levels also appealed to the artist's long-standing preoccupation with entropy.

Smithson's understanding of entropy, drawn from popular science and science fiction alike, fixated on the chance operations of nature that lead to a state of transformation. Created at a time when the lake's water levels were particularly low, the artwork was submerged from 1972 onward, visible only through photographic and film documentation. However, regional droughts thirty years later caused the lake to recede such that the salt-encrusted *Spiral Jetty* reappeared in 2002 for the first prolonged period in its history. The very processes of entropy and temporality that motivated the artist to create it determine the experience of visiting the artwork.

The artist often suggested that *Spiral Jetty* is a site to encounter, rather than a sculpture to behold. In an interview, Smithson explained how the visitor's experience of space shifts as one walks along the work: a "constriction or concentration exists within the inner coils . . . whereas on the outer edge you're kind of thrown out, you're aware of the horizons and how they echo through the *Jetty*."[2] His 1970 film of the same name features, alongside aerial footage, a poetic sequence of the artist running along the spiral to rest at its innermost coil. Interested in the way

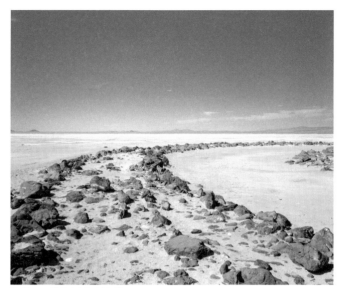

Smithson, *Spiral Jetty* (detail)

his art could be mediated and represented to remote audiences through photography, film, and text, Smithson wrote an essay in 1972 in addition to the film of the same name.

Smithson viewed the land surrounding *Spiral Jetty* not as a timeless backdrop to the work, but instead as a landscape inflected with evolving resonance. Thus, the earthwork existed to him as an open-ended platform to explore, situated within a dynamic spatial and temporal field. Disappearing and reemerging, bound to site and circulated in documentation, the work exists in a state of permanent flux. "One apprehends what is around one's eyes and ears," wrote Smithson, "no matter how unstable or fugitive."[3]

1 Robert Smithson, "Conversation in Salt Lake City" (1972), interview by Gianni Pettena, in *Robert Smithson: The Collected Writings*, ed. Jack Flam (Berkeley: University of California Press, 1996), p. 298.
2 Robert Smithson, "Talking with Robert Smithson," interview by Kenneth Baker, in *Robert Smithson:*

Spiral Jetty, ed. Lynne Cooke et al. (New York: Dia Art Foundation; Berkeley: University of California Press, 2005), p. 158.
3 Robert Smithson, "The Spiral Jetty" (1972), in Cooke, *Robert Smithson*, p. 9.

FURTHER READING

Cooke, Lynne, Bettina Funcke, Karen Kelly, and Barbara Schröder, eds. *Robert Smithson: Spiral Jetty*. New York: Dia Art Foundation; Berkeley: University of California Press, 2005.

Smithson, Robert. *Robert Smithson: The Collected Writings*. Edited by Jack Flam. Berkeley: University of California Press, 1996.

Tsai, Eugenie, ed. *Robert Smithson*. Los Angeles: Museum of Contemporary Art; Berkeley: University of California Press, 2004.

PARTNERSHIPS

Dia partners with Great Salt Lake Institute at Westminster College, Holt/Smithson Foundation, and the Utah Museum of Fine Arts at the University of Utah on initiatives that further advocate for the care and understanding of *Spiral Jetty* and its legacy.

Great Salt Lake Institute, Westminster College, Salt Lake City

Great Salt Lake Institute advises on environmental issues, site maintenance, and accessibility pertaining to *Spiral Jetty*. For more information, visit westminstercollege.edu/campus-life/centers-and-institutes/great-salt-lake -institute.

Holt/Smithson Foundation

Holt/Smithson Foundation exists to continue the creative and investigative spirit of the artists Nancy Holt and Robert Smithson. For more information, visit holtsmithsonfoundation.org.

Utah Museum of Fine Arts, University of Utah, Salt Lake City

The Utah Museum of Fine Arts ensures that *Spiral Jetty*'s cultural reputation is upheld locally and promotes the exceptional significance of the artwork within Utah. For more information, visit umfa.utah.edu.

AFFILIATION

Department of Natural Resources, Utah

The Division of Forestry, Fire, and State Lands within the Department of Natural Resources oversees the lake bed where *Spiral Jetty* is located. For more information, visit naturalresources.utah.gov.

Robert Smithson
The Spiral Jetty (1972)

Red is the most joyful and dreadful thing in the physical universe; it is the fiercest note, it is the highest light, it is the place where the walls of this world of ours wear the thinnest and something beyond burns through.

—G. K. Chesterton

My concern with salt lakes began with my work in 1968 on the Mono Lake Site–Nonsite in California.[1] Later I read a book called *Vanishing Trails of Atacama* by William Rudolph which described salt lakes (salars) in Bolivia in all stages of desiccation, and filled with micro bacteria that give the water surface a red color. The pink flamingos that live around the salars match the color of the water. In *The Useless Land*, John Aarons and Claudio Vita-Finzi describe Laguna Colorada: "The basalt (at the shores) is black, the volcanos purple, and their exposed interiors yellow and red. The beach is grey and the lake pink, topped with the icing of iceberg-like masses of salts."[2] Because of the remoteness of Bolivia and because Mono Lake lacked a reddish color, I decided to investigate the Great Salt Lake in Utah.

From New York City I called the Utah Park Development and spoke to Ted Tuttle, who told me that water in the Great Salt Lake north of the Lucin Cutoff, which cuts the lake in two, was the color of tomato soup. That was enough of a reason to go out there and have a look. Tuttle told my wife, Nancy Holt, and myself of some people who knew the lake. First we visited Bill Holt who lived in Syracuse. He was instrumental in building a causeway that connected Syracuse with Antelope Island in the southern part of the Great Salt Lake. Although that site was interesting, the water lacked the red coloration I was looking for, so we continued our search. Next we went to see John Silver on Silver Sands Beach near Magna. His sons showed us the only boat that sailed the lake. Due to the high salt content of the water it was impractical for ordinary boats to use the lake, and no large boats at all could go beyond the Lucin Cutoff on which the transcontinental railroad crossed

the lake. At that point I was still not sure what shape my work of art would take. I thought of making an island with the help of boats and barges, but in the end I would let the site determine what I would build. We visited Charles Stoddard, who supposedly had the only barge on the north side of the cutoff. Stoddard, a well-driller, was one of the last homesteaders in Utah. His attempt to develop Carrington Island in 1932 ended in failure because he couldn't find fresh water. "I've had the lake," he said. Yet, while he was living on the island with his family he made many valuable observations of the lake. He was kind enough to take us to Little Valley on the east side of the Lucin Cutoff to look for his barge—it had sunk. The abandoned man-made harbors of Little Valley gave me my first view of the wine-red water, but there were too many "Keep Out" signs around to make that a practical site for anything, and we were told to "stay away" by two angry ranchers. After fixing a gashed gas tank, we returned to Charles Stoddard's house north of Syracuse on the edge of some salt marshes. He showed us photographs he had taken of "icebergs,"[3] and Kit Carson's cross carved on a rock on Fremont Island. We then decided to leave and go to Rozel Point.

Driving west on Highway 83 late in the afternoon, we passed through Corinne, then went on to Promontory. Just beyond the Golden Spike Monument, which commemorates the meeting of the rails of the first transcontinental railroad, we went down a dirt road in a wide valley. As we traveled, the valley spread into an uncanny immensity unlike the other landscapes we had seen. The roads on the map became a net of dashes, while in the far distance the Salt Lake existed as an interrupted silver band. Hills took on the appearance of melting solids, and glowed under amber light. We followed roads that glided away into dead ends. Sandy slopes turned into viscous masses of perception. Slowly, we drew near to the lake, which resembled an impassive faint violet sheet held captive in a stony matrix, upon which the sun poured down its crushing light. An expanse of salt flats bordered the lake, and caught in its sediments were countless bits of wreck-age. Old piers were left high and dry. The mere sight of the trapped frag-ments of junk and waste transported one into a world of modern prehistory. The products of a Devonian industry, the remains of a Silurian technology, all the machines of the Upper Carboniferous Period were lost in those expansive deposits of sand and mud.

Two dilapidated shacks looked over a tired group of oil rigs. A series of seeps of heavy black oil more like asphalt occur just south of Rozel Point. For

forty or more years people have tried to get oil out of this natural tar pool. Pumps coated with black stickiness rusted in the corrosive salt air. A hut mounted on pilings could have been the habitation of "the missing link." A great pleasure arose from seeing all those incoherent structures. This site gave evidence of a succession of man-made systems mired in abandoned hopes.

About one mile north of the oil seeps I selected my site. Irregular beds of limestone dip gently eastward, massive deposits of black basalt are broken over the peninsula, giving the region a shattered appearance. It is one of few places on the lake where the water comes right up to the mainland. Under shallow pinkish water is a network of mud cracks supporting the jigsaw puzzle that composes the salt flats. As I looked at the site, it reverberated out to the horizons only to suggest an immobile cyclone while flickering light made the entire landscape appear to quake. A dormant earthquake spread into the fluttering stillness, into a spinning sensation without movement. This site was a rotary that enclosed itself in an immense roundness. From that gyrating space emerged the possibility of the Spiral Jetty. No ideas, no concepts, no systems, no structures, no abstractions could hold themselves together in the actuality of that evidence. My dialectics of site and nonsite whirled into an indeterminate state, where solid and liquid lost themselves in each other. It was as if the mainland oscillated with waves and pulsations, and the lake remained rock still. The shore of the lake became the edge of the sun, a boiling curve, an explosion rising into a fiery prominence. Matter collapsing into the lake mirrored in the shape of a spiral. No sense wondering about classifications and categories, there were none.

After securing a twenty-year lease on the meandering zone,[4] and finding a contractor in Ogden, I began building the jetty in April, 1970. Bob Phillips, the foreman, sent two dump trucks, a tractor, and a large front loader out to the site. The tail of the spiral began as a diagonal line of stakes that extended into the meandering zone. A string was then extended from a central stake in order to get the coils of the spiral. From the end of the diagonal to the center of the spiral, three curves coiled to the left. Basalt and earth were scooped up from the beach at the beginning of the jetty by the front loader, then deposited in the trucks, whereupon the trucks backed up to the outline of stakes and dumped the material. On the edge of the water, at the beginning of the tail, the wheels of the trucks sank into a quagmire of sticky gumbo mud. A whole afternoon was spent filling in this spot. Once the trucks passed that problem, there was always the chance that the salt crust resting

on the mud flats would break through. The Spiral Jetty was staked out in such a way as to avoid the soft muds that broke up through the salt crust, nevertheless there were some mud fissures that could not be avoided. One could only hope that tension would hold the entire jetty together, and it did. A cameraman was sent by the Ace Gallery in Los Angeles to film the process.

The scale of the Spiral Jetty tends to fluctuate depending on where the viewer happens to be. Size determines an object, but scale determines art. A crack in the wall if viewed in terms of scale, not size, could be called the Grand Canyon. A room could be made to take on the immensity of the solar system. Scale depends on one's capacity to be conscious of the actualities of perception. When one refuses to release scale from size, one is left with an object or language that *appears* to be certain. For me scale operates by uncertainty. To be in the scale of the Spiral Jetty is to be out of it. On eye level, the tail leads one into an undifferentiated state of matter. One's downward gaze pitches from side to side, picking out random depositions of salt crystals on the inner and outer edges, while the entire mass echoes the irregular horizons. And each cubic salt crystal echoes the Spiral Jetty in terms of the crystal's molecular lattice. Growth in a crystal advances around a dislocation point, in the manner of a screw. The Spiral Jetty could be considered one layer within the spiraling crystal lattice, magnified trillions of times.

This description echoes and reflects [Constantin] Brancusi's sketch of James Joyce as a "spiral ear" because it suggests both a visual and an aural scale, in other words it indicates a sense of scale that resonates in the eye and the ear at the same time. Here is a reinforcement and prolongation of spirals that reverberates up and down space and time. So it is that one ceases to consider art in terms of an "object." The fluctuating resonances reject "objective criticism," because that would stifle the generative power of both visual and auditory scale. Not to say that one resorts to "subjective concepts," but rather that one apprehends what is around one's eyes and ears, no matter how unstable or fugitive. One seizes the spiral, and the spiral becomes a seizure.

After a point, measurable steps ("Scale skal n. It. or L; It. *Scala*; L *scala* usually *scalae* pl., I. a. originally a ladder; a flight of stairs; hence, b. a means of ascent"[5]) descend from logic to the "surd state." The rationality of a grid on a map sinks into what it is supposed to define. Logical purity suddenly finds itself in a bog, and welcomes the unexpected event. The "curved" reality of sense perception operates in and out of the "straight" abstractions of the

mind. The flowing mass of rock and earth of the Spiral Jetty could be trapped by a grid of segments, but the segments would exist only in the mind or on paper. Of course, it is also possible to translate the mental spiral into a three-dimensional succession of measured lengths that would involve areas, volumes, masses, moments, pressures, forces, stresses, and strains; but in the Spiral Jetty the surd takes over and leads one into a world that cannot be expressed by number or rationality. Ambiguities are admitted rather than rejected, contradictions are increased rather than decreased—the *alogos* undermines the *logos*. Purity is put in jeopardy. I took my chances on a perilous path, along which my steps zigzagged, resembling a spiral lightning bolt. "We have found a strange footprint on the shores of the unknown. We have devised profound theories, one after another, to account for its origin. At last, we have succeeded in constructing the creature that made the footprint. And lo! it is our own."[6] For my film (a film is a spiral made up of frames) I would have myself filmed from a helicopter (from the Greek *helix*, *helikos* meaning spiral) directly overhead in order to get the scale in terms of erratic steps.

Chemically speaking, our blood is analogous in composition to the primordial seas. Following the spiral steps we return to our origins, back to some pulpy protoplasm, a floating eye adrift in an antediluvian ocean. On the slopes of Rozel Point I closed my eyes, and the sun burned crimson through the lids. I opened them and the Great Salt Lake was bleeding scarlet streaks. My sight was saturated by the color of red algae circulating in the heart of the lake, pumping into ruby currents, no they were veins and arteries sucking up the obscure sediments. My eyes became combustion chambers churning orbs of blood blazing by the light of the sun. All was enveloped in a flaming chromosphere; I thought of Jackson Pollock's *Eyes in the Heat* (1946; Peggy Guggenheim Collection). Swirling within the incandescence of solar energy were sprays of blood. My movie would end in sunstroke. Perception was heaving, the stomach turning, I was on a geologic fault that groaned within me. Between heat lightning and heat exhaustion the spiral curled into vaporization. I had the red heaves, while the sun vomited its corpuscular radiations. Rays of glare hit my eyes with the frequency of a Geiger counter. Surely, the storm clouds massing would turn into a rain of blood. Once, when I was flying over the lake, its surface seemed to hold all the properties of an unbroken field of raw meat with gristle (foam); no doubt it was due to some

freak wind action. Eyesight is often slaughtered by the other senses, and when that happens it becomes necessary to seek out dispassionate abstractions. The dizzying spiral yearns for the assurance of geometry. One wants to retreat into the cool rooms of reason. But no, there was Vincent Van Gogh with his easel on some sun-baked lagoon painting ferns of the Carboniferous Period. Then the mirage faded into the burning atmosphere.

From the center of the Spiral Jetty.

North—Mud, salt crystals, rocks, water
North by East—Mud, salt crystals, rocks, water
Northeast by North—Mud, salt crystals, rocks, water
Northeast by East—Mud, salt crystals, rocks, water
East by North—Mud, salt crystals, rocks, water
East—Mud, salt crystals, rocks, water
East by South—Mud, salt crystals, rocks, water
Southeast by East—Mud, salt crystals, rocks, water
Southeast by South—Mud, salt crystals, rocks, water
South by East—Mud, salt crystals, rocks, water
South—Mud, salt crystals, rocks, water
South by West—Mud, salt crystals, rocks, water
Southwest by South—Mud, salt crystals, rocks, water
Southwest by West—Mud, salt crystals, rocks, water
West by South—Mud, salt crystals, rocks, water
West—Mud, salt crystals, rocks, water
West by North—Mud, salt crystals, rocks, water
Northwest by West—Mud, salt crystals, rocks, water
Northwest by North—Mud, salt crystals, rocks, water
North by West—Mud, salt crystals, rocks, water

The helicopter maneuvered the sun's reflection through the Spiral Jetty until it reached the center. The water functioned as a vast thermal mirror. From that position the flaming reflection suggested the ion source of a cyclotron that extended into a spiral of collapsed matter. All sense of energy acceleration expired into a rippling stillness of reflected heat. A withering light swallowed the rocky particles of the spiral, as the helicopter gained altitude. All existence seemed tentative and stagnant. The sound of the helicopter motor became a primal groan echoing into tenuous aerial views. Was I but a

shadow in a plastic bubble hovering in a place outside mind and body? *Et in Utah ego.* I was slipping out of myself again, dissolving into a unicellular beginning, trying to locate the nucleus at the end of the spiral. All that blood stirring makes one aware of protoplasmic solutions, the essential matter between the formed and the unformed, masses of cells consisting largely of water, proteins, lipoids, carbohydrates, and inorganic salts. Each drop that splashed onto the Spiral Jetty coagulated into a crystal. Undulating waters spread millions upon millions of crystals over the basalt.

The preceding paragraphs refer to a "scale of centers" that could be disentangled as follows:

(a) ion source in cyclotron

(b) a nucleus

(c) dislocation point

(d) a wooden stake in the mud

(e) axis of helicopter propeller

(f) James Joyce's ear channel

(g) the Sun

(h) a hole in the film reel.

Spinning off of this uncertain scale of centers would be an equally uncertain "scale of edges":

(a) particles

(b) protoplasmic solutions

(c) dizziness

(d) ripples

(e) flashes of light

(f) sections

(g) foot steps

(h) pink water.

The equation of my language remains unstable, a shifting set of coordinates, an arrangement of variables spilling into surds. My equation is as clear as mud—a muddy spiral.

Back in New York, the urban desert, I contacted Bob Fiore and Barbara Jarvis and asked them to help me put my movie together. The movie began as a set of disconnections, a bramble of stabilized fragments taken from things obscure and fluid, ingredients trapped in a succession of frames, a stream of

viscosities both still and moving. And the movie editor, bending over such a chaos of "takes" resembles a paleontologist sorting out glimpses of a world not yet together, a land that has yet to come to completion, a span of time unfinished, a spaceless limbo on some spiral reels. Film strips hung from the cutter's rack, bits and pieces of Utah, out-takes overexposed and underexposed, masses of impenetrable material. The sun, the spiral, the salt buried in lengths of footage. Everything about movies and moviemaking is archaic and crude. One is transported by this Archeozoic medium into the earliest known geological eras. The movieola becomes a "time machine" that transforms trucks into dinosaurs. Fiore pulled lengths of film out of the movieola with the grace of a Neanderthal pulling intestines from a slaughtered mammoth. Outside his 13th Street loft window one expected to see Pleistocene faunas, glacial uplifts, living fossils, and other prehistoric wonders. Like two cavemen we plotted how to get to the Spiral Jetty from New York City. A geopolitics of primordial return ensued. How to get across the geography of Gondwanaland, the Austral Sea, and Atlantis became a problem. Consciousness of the distant past absorbed the time that went into the making of the movie. I needed a map that would show the prehistoric world as coextensive with the world I existed in.

I found an oval map of such a double world. The continents of the Jurassic Period merged with continents of today. A microlense fitted to the end of a camera mounted on a heavy tripod would trace the course of "absent images" in the blank spaces of the map. The camera panned from right to left. One is liable to see things in maps that are not there. One must be careful of the hypothetical monsters that lurk between the map's latitudes; they are designated on the map as black circles (marine reptiles) and squares (land reptiles). In the pan shot one doesn't see the flesh-eaters walking through what today is called Indochina. There is no indication of Pterodactyls flying over Bombay. And where are the corals and sponges covering southern Germany? In the emptiness one sees no Stegosaurus. In the middle of the pan we see Europe completely under water, but not a trace of the Brontosaurus. What line or color hides the Globigerina Ooze? I don't know. As the pan ends near Utah, on the edge of Atlantis, a cut takes place, and we find ourselves looking at a rectangular grid known as Location NK 12-7 on the border of a map drawn by the U.S. Geological Survey showing the northern part of the Great Salt Lake without any reference to the Jurassic Period.

. . . the earth's history seems at times like a story recorded in a book each
page of which is torn into small pieces. Many of the pages and some of the
pieces of each page are missing . . .[7]

I wanted Nancy to shoot "the earth's history" in one minute for the third
section of the movie. I wanted to treat the above quote as a "fact." We drove
out to the Great Notch Quarry in New Jersey, where I found a quarry facing
about twenty feet high. I climbed to the top and threw handfuls of ripped-up
pages from books and magazines over the edge, while Nancy filmed it. Some
ripped pages from an Old Atlas blew across a dried out, cracked mud puddle.

According to all we know from fossil anatomy that beast was comparatively
harmless. Its only weapons were its teeth and claws. I don't know what
those obscene looking paunches mean—they don't show in any fossil
remains yet found. Nor do I know whether red is their natural color, or
whether it is due to faster decay owing to all the oil having dripped down
off them. So much for its supposed identity.[8]

The movie recapitulates the scale of the Spiral Jetty. Disparate elements
assume a coherence. Unlikely places and things were stuck between sections
of film that show a stretch of dirt road rushing to and from the actual site
in Utah. A road that goes forward and backward between things and places
that are elsewhere. You might even say that the road is nowhere in particular.
The disjunction operating between reality and film drives one into a sense
of cosmic rupture. Nevertheless, all the improbabilities would accommodate
themselves to my cinematic universe. Adrift amid scraps of film, one is
unable to infuse into them any meaning, they seem worn-out, ossified views,
degraded and pointless, yet they are powerful enough to hurl one into a lucid
vertigo. The road takes one from a telescopic shot of the sun to a quarry in
Great Notch New Jersey, to a map showing the "deformed shorelines of
ancient Lake Bonneville," to *The Lost World*, and to the Hall of Late Dinosaurs
in the American Museum of Natural History.

The hall was filmed through a red filter. The camera focuses on a
Ornithominus Altus embedded in plaster behind a glass case. A pan across
the room picked up a crimsom chiaroscuro tone. There are times when the
great outdoors shrinks phenomenologically to the scale of a prison, and
times when the indoors expands to the scale of the universe. So it is with the
sequence from the Hall of Late Dinosaurs. An interior immensity spreads
throughout the hall, transforming the lightbulbs into dying suns. The red

filter dissolves the floor, ceiling, and walls into halations of infinite redness. Boundless desolation emerged from the cinematic emulsions, red clouds, burned from the intangible light beyond the windows, visibility deepened into ruby dispersions. The bones, the glass cases, the armatures brought forth a blood-drenched atmosphere. Blindly the camera stalked through the sullen light. Glassy reflections flashed into dissolutions like powdered blood. Under a burning window the skull of a Tyrannosaurus was mounted in a glass case with a mirror under the skull. In this limitless scale one's mind imagines things that are not there. The bloodsoaked dropping of a sick Duck-Billed Dinosaur, for instance. Rotting monster flesh covered with millions of red spiders. Delusion follows delusion. The ghostly cameraman slides over the glassed-in compounds. These fragments of a timeless geology laugh without mirth at the time-filled hopes of ecology. From the soundtrack the echoing metronome vanishes into the wilderness of bones and glass. Tracking around a glass containing a "dinosaur mummy," the words of *The Unnamable* are heard. The camera shifts to a specimen squeezed flat by the weight of sediments, then the film cuts to the road in Utah.

1 Dialectic of Site and Nonsite

Site	Nonsite
1. Open Limits	Closed Limits
2. A Series of Points	An Array of Matter
3. Outer Coordinates	Inner Coordinates
4. Subtraction	Addition
5. Indeterminate Certainty	Determinate Uncertainty
6. Scattered Information	Contained Information
7. Reflection	Mirror
8. Edge	Center
9. Some Place (physical)	No Place (abstract)
10. Many	One

Range of Convergence

The range of convergence between Site and Nonsite consists of a course of hazards, a double path made up of signs, photographs, and maps that belong to both sides of the dialectic at once. Both sides are present and absent at the same time. The land or ground from the Site is placed *in* the art (Nonsite) rather than the art placed *on* the ground. The Nonsite is a container within another container—the room. The plot or yard outside is yet another container. Two-dimensional and three-dimensional things trade places with each other in the range of convergence. Large scale becomes small. Small scale becomes large. A point on a map expands to the size of a land mass. A land mass contracts into a point. Is the Site a reflection of the Nonsite (*mirror*), or is it the other way around? The rules of this network of signs are discovered as you go along uncertain trails both mental and physical.

"No fish or reptile lives in it (Mono Lake), yet it swarms with millions of worms which develop into flies. These rest on the surface and cover everything on the immediate shore. The number and quantity of those worms and flies is absolutely incredible. They drift up in heaps along the shore." W. H. Brewer, *The Whitney Survey on Mount Shasta*, 1863.

2 John Aarons and Claudio Vita-Finzi, *The Useless Land* (London: Robert Hale, 1960), p. 129.

3 "In spite of the concentrated saline quality of the water, ice is often formed on parts of the Lake. Of course, the lake brine does not freeze; it is far too salty for that. What actually happens is that during relatively calm weather, fresh water from the various streams flowing into the lake 'floats' on top of the salt water, the two failing to mix. Near mouths of rivers and creeks this 'floating' condition exists at all times during calm weather. During the winter this fresh water often freezes before it mixes with the brine. Hence, an ice sheet several inches thick has been known to extend from Weber River to Fremont Island, making it possible for coyotes to cross to the island and molest sheep pastured there. At times this ice breaks loose and floats about the lake in the form of 'icebergs.'" David E. Miller, *Great Salt Lake Past and Present* (Salt Lake City, 1949).

4 *Township 8 North of Range 7 West of the Salt Lake Base and Meridian*: Unsurveyed land on the bed of the Great Salt Lake, if surveyed, would be described as follows: Beginning at a point South 3000 feet and West 800 feet from the Northeast Corner of Section 8, Township 8 North, Range 7 West; thence South 45° West 651 feet; thence North 60° West 651 feet; thence North 45° East 651 feet; thence Southeasterly along the meander line 675 feet to the point of beginning. Containing 1000 acres, more or less. *Special Use Lease Agreement No. 222*; witness: Mr. Mark Crystal.

5 *Webster's New World Dictionary of the American Language*, college ed. (1959), s.v. "scale."

6 A. S. Eddington, quoted in Tobias Dantzig, *Number: The Language of Science* (New York: Doubleday Anchor Books, 1954), p. 232.

7 Thomas H. Clark and Colin W. Stearn, *Geological Evolution of North America* (New York: Ronald Press Co., 1960), p. 5.

8 John Taine, *The Greatest Adventure: Three Science Fiction Novels* (New York: Dover Publications, 1963), p. 239.

Time Line of Locations and Sites

This time line presents Dia Art Foundation's major locations for changing exhibitions, performances, and public programs, and sites for single-artist projects or site-specific artworks since the organization's founding. All dates reflect Dia's initial or continued involvement with a given project.

1974

Dia Art Foundation is founded by Fariha Friedrich, Heiner Friedrich, and Helen Winkler Fosdick to promote the development of experimental artworks, primarily those that could not otherwise be realized due to their nature or size, and facilitate their long-term, public viewing. In its first year, Dia contributes funding and organizational support to major Land art initiatives such as James Turrell's *Roden Crater* (1977–) near Flagstaff, Arizona.

1975

Dan Flavin, *untitled in pink, green, and blue fluorescent light*
Kunstmuseum Basel
Dia gifts the Kunstmuseum Basel this permanent outdoor installation by Flavin that consists of fluorescent light works placed in the front and arcade corners of the museum's building.

1975–79

La Monte Young and Marian Zazeela, *Dream Festival*
141 Wooster Street, New York
Young and Zazeela receive a ten-year commission from Dia and inaugurate the *Dream Festival*, which includes, within a *Dream House* sound-and-light environment, the American premiere of Young's *The Well-Tuned Piano* (1964–73–81–), the exhibition *Marian Zazeela: Lights, Drawings* (1975), the Theatre of Eternal Music performances, and Pandit Pran Nath Raga concerts (1978), copresented at 393 West Broadway with the Kirana Center for Indian Classical Music, New York. In 1979 the artists move their activities from the foundation's administrative offices to a dedicated location at 6 Harrison Street.

1

1976–87
Flavin, *untitled* (1976–77)
Grand Central Terminal, New York
Flavin conceives of a long-term public installation at Grand Central for *200 Years of American Sculpture*, Whitney Museum of American Art, New York (1976). As the work is beyond the scope of the show, it is realized with Dia's financial and logistical support in partnership with the Metropolitan Transit Authority (MTA) Arts for Transit, the first of several collaborations between Dia and MTA Arts.

2

1977
Walter De Maria, *The Lightning Field*
Western New Mexico
De Maria's earthwork, under development since 1974 and commissioned by Dia, opens in a limited capacity. Dia has operated *The Lightning Field* since the opening. See pages 51, 53–55, 57, 59–61.

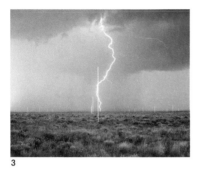

3

1977
De Maria, *The New York Earth Room*
141 Wooster Street, New York
De Maria installs his third *Earth Room* in
Friedrich's gallery adjacent to Dia's former
administrative offices. This same year Dia
converts the space into a permanent public
installation, on view since the opening except
for brief renovations in 1978–79. See pages
51, 53, 57.

1977
De Maria, *The Vertical Earth Kilometer*
Friedrichsplatz Park, Kassel,
West Germany
Realized in collaboration with Documenta and
Dia, this vertical sculpture is a publicly accessible
landmark in Kassel. With the city's approval,
the site remains one of Dia's permanent
installations. See pages 51, 53, 55, 57.

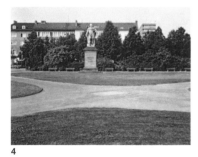

4

1979
De Maria, *The Broken Kilometer*
393 West Broadway, New York
De Maria's *The Broken Kilometer*, a
companion piece to *The Vertical Earth
Kilometer*, is installed and becomes a per-
manent Dia site. See pages 51, 53, 55, 57.

5

1979–85
**Robert Whitman, Robert Whitman
Projects**
512 West 19th Street, New York
Dia maintains this former soundstage as a
studio for and space to present works by
Whitman, including *Prune Flat* (1965), *Light
Touch* (1978), and *Raincover* (1983). The
project closes in 1985.

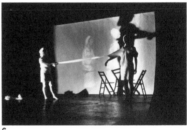

6

1979–86
Donald Judd, Marfa Project (1978–)
Marfa, Texas
Dia helps Judd establish a permanent site
to showcase his work and that of a select
group of his peers. Funded and adminis-
tered by Dia from 1979 to 1986, this
project, which Judd began in 1978, is
now operated by the Chinati Foundation.

7

1980–83
Dia Cologne
Bismarckstraße 50, Cologne, West Germany
The foundation's outpost in West Germany opens in September 1980 with an exhibition of works by Blinky Palermo, followed in 1981 by Lucio Fontana and Imi Knoebel. From the Cologne offices, Dia coordinates donations for Joseph Beuys's *7000 Eichen* (*7000 Oaks*), to be inaugurated in 1982 at Documenta in Kassel, West Germany. The location closes in 1983.

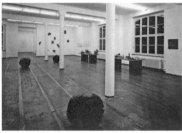
8

1981–85
Young and Zazeela, *Dream House* (1979–85)
6 Harrison Street, New York
Young, Zazeela, and Pandit Pran Nath move into this space to live and work. They install a *Dream House* environment (1979–85), which includes Zazeela's *The Magenta Lights* (1980–) and is open to the public between 1981 and 1985. The space is also used as a rehearsal hall, holds archives for the artists' work, and is a center for teaching the Kirana style of North Indian classical music.

9

1981–87
Masjid al-Farah, with Flavin installation
155 Mercer Street, New York
Together with Sheikh Muzaffer Ozak Ashki al-Jerrahi, leader of the Halveti-Jerrahi Order of Dervishes of Istanbul, Dia establishes and maintains this Sufi mosque until 1985. In 1982 Dia commissions a series of untitled light sculptures by Flavin, presented throughout the building and on view until 1987.

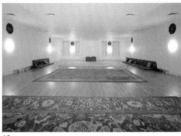
10

1981–96
The Fred Sandback Museum
74 Front Street, Winchendon, Massachusetts
Renovated and maintained by Dia, this former bank presents sculptural installations and graphic works by Sandback.

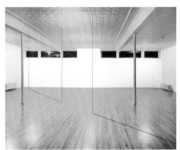
11

1982
Dia SoHo
77 Wooster Street, New York

Intended for the long-term exhibition of paintings by Barnett Newman, on view between 1982 and 1985, this building later shows exhibitions of works by Andy Warhol and projects by Group Material and Martha Rosler from 1985 to 1989. After consolidating its exhibition programs in Chelsea, Dia subsequently leases the space to various local businesses. In 2023 77 Wooster Street will reopen under the name Dia SoHo to host changing exhibitions and accompanying programs.

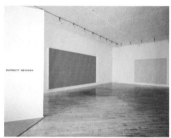

12

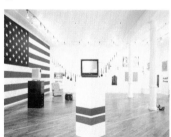

13

14

1982–84
John Chamberlain, Chamberlain Gardens
Essex, Connecticut

Dia maintains an installation of Chamberlain's sculpture in the ten-acre garden at his former outdoor studio on the Connecticut River.

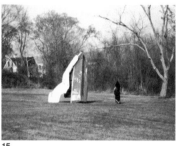

15

1982–85
John Chamberlain: Sculpture, An Extended Exhibition
67 Vestry Street, New York

Dia presents rotating exhibitions of Chamberlain's work, including metal and foam sculptures, drawings, and Widelux photographs, in the artist's former Tribeca studio.

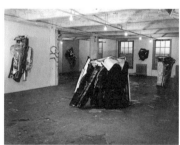

16

1983
Dia Bridgehampton
23 Corwith Avenue, Bridgehampton, New York
In close consultation with the artist, Dia establishes the Dan Flavin Art Institute, a permanent space on Long Island for light works by Flavin as well as temporary exhibitions of work by local artists. Now known as Dia Bridgehampton, the building houses Flavin's immersive permanent installation, *nine sculptures in fluorescent light* (1963–81) on the upper floor, while the ground floor features changing year-long exhibitions. See pages 31–35.

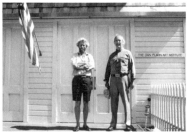
17

1986-96
155 Mercer Street, New York
Following the closing of Masjid al-Farah, Dia establishes 155 Mercer Street as a space for programs, especially modern dance rehearsals, performances, and educational activities showcasing works by over ninety choreographers. Through the Salon Project (1986–95), each year Dia presents three concerts of works by choreographers chosen from those rehearsing in the building during the prior year. In fall 1987 Readings in Contemporary Poetry, Dia's longest-running program, begins. Also at 155 Mercer, Dia hosts Discussions in Contemporary Culture (1987–), a series of panel discussions and symposia.

1987
Dia Chelsea
535, 537, 541, 545, and 548 West 22nd Street, New York
Starting in 1987, Dia presents commissions and changing exhibitions in three buildings on West Twenty-Second Street: 541 (2011–), 545 (1992–), and 548 (1987–2004). In 2001 the lecture series Artists on Artists begins on the fifth floor of 535, the building in which the administrative offices are located. After a period of renovation in 2019–20, Dia Chelsea reopens in the now-connected buildings of 535, 541, and 545 in spring 2021 as 537. See pages 37–39.

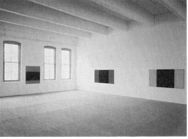
18

1988
Joseph Beuys, *7000 Eichen* (*7000 Oaks*) (inaugurated in 1982 and ongoing)
West 22nd Street between and including 10th and 11th Avenues, New York
7000 Eichen (*7000 Oaks*) is a long-term installation by Beuys, inaugurated with major support from Dia as part of Documenta in Kassel in 1982. Dia extends the project to New York in 1988, incrementally adding trees and basalt stones in 1996 and 2020 for a total of thirty-eight pairs. See pages 41–49.

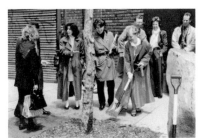
19

1993
Andy Warhol Museum
Pittsburgh

Working closely with a joint committee that includes the Carnegie Institute and the Andy Warhol Foundation for the Visual Arts, both Pittsburgh, Dia helps establish the Andy Warhol Museum in the former Volkwein Building. Dia donates the majority of its Warhol works to the museum's founding collection.

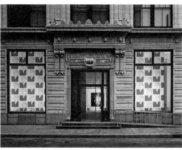

20

1996
Flavin at Chiesa Rossa
Milan

In collaboration with Fondazione Prada and Flavin's estate, Dia completes a fluorescent light installation specifically designed by the artist, who passes away this year, for the Santa Maria Annunciata in Chiesa Rossa church in Milan.

1998
Cy Twombly Gallery at the Menil Collection
Houston

This permanent, Renzo Piano–designed pavilion dedicated to Twombly's work opens through a partnership among Dia, the Menil, and the artist.

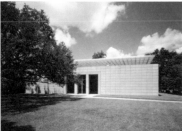

21

1999
Robert Smithson, *Spiral Jetty* (1970)
Rozel Point, Great Salt Lake, Box Elder County, Utah

Dia acquires and assumes stewardship of Smithson's iconic work of Land art in Utah's Great Salt Lake. See pages 83–97.

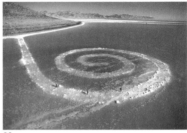

22

2002
Max Neuhaus, *Times Square* (1977)
Triangular pedestrian plaza at Broadway and 7th Avenue south of 46th Street, New York

First installed in 1977 and audible until 1992, Neuhaus's *Times Square* is relaunched as a permanent Dia site, thanks to a collaboration among the foundation, gallery owner Christine Burgin, MTA Arts for Transit, the Times Square Street Business Improvement District, and various individual supporters. See pages 77–81.

23

2003

Dia Beacon
Riggio Galleries
3 Beekman Street, Beacon, New York
Located along the Hudson River, this
renovated factory, which made labels
and boxes for Nabisco, opens and serves
as a permanent home for Dia's collection,
as well as for temporary exhibitions,
commissioned performances, and public
programs. See pages 25–29.

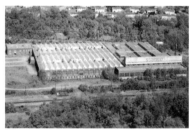
24

2007

George Trakas, *Beacon Point*
Long Dock Park, Beacon, New York
Initiated in 1999 by Dia, *Beacon Point* is
realized in collaboration with the organiza-
tions Scenic Hudson and Minetta Brook.
Situated on Scenic Hudson's twenty-five-
acre Long Dock Park along the waterfront
adjacent to Dia Beacon, Trakas's project
includes a terraced angling deck, new
boardwalk, and restored bulkhead and
parts of the shoreline.

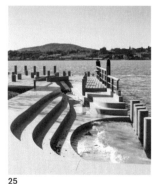
25

2007–11

Dia at the Hispanic Society of America
613 West 155th Street, New York
In collaboration with the Hispanic Society
of America, Dia commissions projects by
artists Francis Alÿs, Dominique Gonzalez-
Foerster, and Koo Jeong A that are
presented at the Hispanic Society's historic
Beaux Arts building. Dia also organizes
Tuesdays on the Terrace, a series of
outdoor public programs that feature
dance, music, poetry, and more.

26

2013

Thomas Hirschhorn, *Gramsci Monument*
Forest Houses, Bronx, New York
Hirschhorn's *Gramsci Monument* is
installed, July 1–September 15, on the
grounds of the New York City Housing
Authority's Forest Houses. Constructed
and managed by local residents, the
outdoor structure of numerous pavilions
includes an exhibition space with objects
that belonged to the Italian Marxist writer
and politician Antonio Gramsci, a library,
stage, art workshop, computer space, and
restaurant. The project offers art classes,
a newspaper, a radio show, and poetry
readings, among other programs.

27

2015–18
Jennifer Allora and Guillermo Calzadilla,
Puerto Rican Light (Cueva Vientos) **(2015)**
Between Guayanilla and Peñuelas,
Puerto Rico
This commission by artist duo Allora &
Calzadilla is sited in a natural limestone
cave near the southern coast of Puerto
Rico. Organized in collaboration with
two regional partners, Museo de Arte de
Ponce and Para la Naturaleza, the project
integrates the journey to the site as part
of the viewers' experience and epitomizes
the artists' shared interest in confronting
contemporary spectatorship with the
deepest layers of the human past.

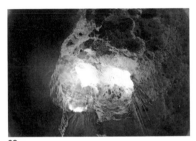

28

2018
Nancy Holt, *Sun Tunnels* **(1973–76)**
Great Basin Desert, Box Elder County,
Utah
Dia acquires Holt's *Sun Tunnels* with
support from Holt/Smithson Foundation.
See pages 63–75.

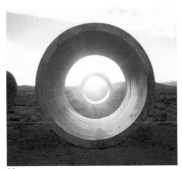

29

1 The Theatre of Eternal Music (La Monte Young, voice and frequency generators; Marian Zazeela, Sharon Stone, and Alex Dea, voices; Jon Hassell, horn; and Wayne Forrest, tuba) performing La Monte Young Marian Zazeela's "Map of 49's Dream The Two Systems of Eleven Sets of Galactic Intervals Ornamental Lightyears Tracery" (1966–) in La Monte Young Marian Zazeela, *Dream House*, 141 Wooster Street, New York, 1975

2 Dan Flavin, *untitled*, 1976–77. Pink, daylight, and yellow fluorescent light, three parts: approx. 1,000 feet (300 m) long each. Installation view, Grand Central Terminal, New York, 1976–87

3 Walter De Maria, *The Lightning Field* (detail), western New Mexico, 1977. Stainless-steel poles, 400 parts: one mile by one kilometer. Dia Art Foundation

4 Walter De Maria, *The Vertical Earth Kilometer* (detail), Friedrichsplatz, Kassel, Germany, 1977. Brass, 3280 feet, 10⅜ inches × 2 inches × 2 inches (1 km × 5 cm × 5 cm). Dia Art Foundation

5 Walter De Maria, *The Broken Kilometer* (detail), 1979. Brass, 500 parts: 2 × 78¾ × 2 inches (5 × 200 × 5 cm) each. Dia Art Foundation. Installation view, 393 West Broadway, New York

6 Babette Mangolte, *Prune Flat*, 1976. Photographic print, 8 × 10 inches (20.3 × 25.4 cm)

7 Donald Judd, *15 untitled works in concrete*, 1980–84. Concrete, 15 parts: 98⅜ inches × 98¾ inches × 16 feet, 4 inches (2.5 × 2.5 × 5 m) each. Chinati Foundation, Marfa, Texas

8 *Lucio Fontana*, installation view, Dia Cologne, West Germany, 1981

9 6 Harrison Street, New York

10 Dan Flavin, installation view, Masjid al-Farah, 155 Mercer Street, New York, 1982–87

11 Fred Sandback *Untitled (from Ten Vertical Constructions)* (detail), 1977–79. Black acrylic yarn, spatial relationships established by the artist; overall dimensions vary with each installation. Dia Art Foundation. *Fred Sandback*, installation view, Fred Sandback Museum, Winchendon, Massachusetts, June 20, 1981–October 31, 1982

12 *Barnett Newman: Four Paintings, 1952– 1968*, installation view, 77 Wooster Street, New York, February 26, 1982–March 1984. From left to right: *Anna's Light*, 1968, and *The Moment I*, 1962

13 Group Material, *Democracy: AIDS and Democracy; A Case Study*, installation view, 77 Wooster Street, New York, December 17, 1988–January 14, 1989

14 Martha Rosler, *If You Lived Here . . .*, installation view, 77 Wooster Street, New York, February 11–June 17, 1989

15 John Chamberlain, *Luftschloss*, 1979. Painted and chromium-plated steel, 152 × 103 × 83 inches (386.1 × 261.6 × 210.8 cm). Dia Art Foundation. Installation view, Chamberlain Gardens, Essex, Connecticut

16 *John Chamberlain, An Extended Exhibition*, installation view, 67 Vestry Street, New York, March 19–November 27, 1982. From left to right: *Kunststecher*, 1977; *Daddy-O-Springs*, 1975; *Roxanne Loup*, 1979; *Hi Jinks*, 1979; and *Abba Funn*, 1979

17 Donald Judd and Dan Flavin outside the Dan Flavin Art Institute, Bridgehampton, New York, 1983

18 Blinky Palermo, *To the People of New York City* (detail), 1976. Acrylic on aluminum, 40 panels: dimensions variable. Dia Art Foundation. Installation view, 548 West Twenty-Second Street, New York, October 9, 1987–June 19, 1988

19 Tree planting ceremony for Joseph Beuys, *7000 Eichen* (*7000 Oaks*), at Dia Center for the Arts, West Twenty-Second Street, New York, May 8, 1996

20 Andy Warhol Museum, Pittsburgh, 2013

21 Cy Twombly Gallery, Menil Collection, Houston, 1995

22 Robert Smithson, *Spiral Jetty*, Rozel Point, Great Salt Lake, Box Elder County, Utah, 1970. Black basalt, salt crystals, earth, and water, approximately 1,500 feet long × 15 feet wide (457 × 4.5 m); approximately 328 × 492 feet (100 × 150 m) overall. Dia Art Foundation

23 Max Neuhaus installing *Times Square*, 1977

24 Nabisco factory, Beacon, New York, ca. 2000

25 George Trakas, *Beacon Point* (detail), 2007. Steel, wood, and stone, 480 feet long × 255 feet wide (146.3 × 77.7 m)

26 Terrace Sculpture and Upper Terrace, Hispanic Society of America, New York

27 Thomas Hirschhorn, Art School : Energy=Yes ! Quality=No ! workshop as part of *Gramsci Monument*, Forest Houses, Bronx, New York, 2013

28 Jennifer Allora and Guillermo Calzadilla, *Puerto Rican Light (Cueva Vientos)*, cave between Guayanilla and Peñuelas, Puerto Rico, 2015. Dan Flavin's *Puerto Rican light (to Jeanie Blake) 2* (1965), solar-gel batteries and panels, charge controller, inverter charger, cables, and solar energy collected in San Juan, Puerto Rico. Courtesy the artists

29 Nancy Holt, *Sun Tunnels* (detail), Great Basin Desert, Box Elder County, Utah, 1973–76. Concrete, steel, and earth, four parts: 18 feet, 1 inch × 9 feet, 3 inches diameter (5.5 × 2.8 m) each; 9 feet, 3 inches × 68 feet, 6 inches × 53 feet (2.8 × 20.9 × 16.2 m) overall. Dia Art Foundation with support from Holt/Smithson Foundation

Page 10 photo courtesy Dia Art Foundation Archives; page 13 © La Monte Young and Marian Zazeela, photo John Cliett; pages 15, 100 (fig. 10) © Stephen Flavin/Artists Rights Society (ARS), New York, photo Carol Huebner Venezia; pages 17, 24, 27 (top), 30 photo Bill Jacobson Studio, New York; page 18 © Katharina Fritsch/Artists Rights Society (ARS), New York/ VG Bild-Kunst, Bonn, photo Bill Jacobson Studio, New York; page 19 © Muna Tseng, photo Nan Melville; page 20 © Francis Alÿs, photo Cathy Carver; page 27 (bottom) © Fred Sandback Archive, photo Bill Jacobson Studio, New York; page 28 (top) © Robert Irwin/Artists Rights Society (ARS), New York; page 28 (bottom) photo Ken Goebel; page 32 © Stephen Flavin/Artists Rights Society (ARS), New York, photo Bill Jacobson Studio, New York; page 34 © Mary Heilmann, photo Bill Jacobson Studio, New York; page 36 Don Stahl; page 38 © Dan Graham, photo Bill Jacobson Studio, New York, page 40 © Joseph Beuys/Artists Rights Society (ARS), New York/VG Bild-Kunst, Bonn, photo Don Stahl; pages 50, 52, 99 (fig. 3) © Estate of Walter De Maria, photo John Cliett; pages 54, 99 (fig. 4) © Estate of Walter De Maria, photo Nic Tenwiggenhorn; pages 56, 99 (fig. 5) © Estate of Walter De Maria, photo Jon Abbott; pages 62, 65, 82, 85 © Holt/Smithson Foundation and Dia Art Foundation/Licensed by VAGA at Artists Rights Society (ARS), New York, photo Victoria Sambunaris; page 76 © Estate of Max Neuhaus, photo Don Stahl; pages 79, 103 (fig. 23) © Estate of Max Neuhaus; page 98 (fig. 1) © La Monte Young and Marian Zazeela, photo A. C. Conrad; pages 98 (fig. 2), 102 (fig. 17) © Stephen Flavin/Artists Rights Society (ARS), New York; page 99 (fig 6) © Babette Mangolte; page 99

Dia Art Foundation
535 West 22nd Street
New York, New York 10011
diaart.org

Distributed by
ARTBOOK | D.A.P.
75 Broad Street, Suite 630
New York, New York 10004
artbook.com

Book design: Laura Fields
Editors: Kamilah N. Foreman and Sophia Larigakis
Rights and reproduction: Mollie Bernstein
Proofreader: Katherine Atkins
Map: Anandaroop Roy

Typeset in Berthold Akzidenz Grotesk and Adobe Caslon Pro

Printed on 120 gsm Extra smooth white

Printed and bound in Belgium by die Keure

ISBN 978-0-944521-92-2

Library of Congress Control Number: 2020949789

Dia Beacon
Riggio Galleries
3 Beekman Street
Beacon, New York

Dia Bridgehampton
The Dan Flavin Art Institute
23 Corwith Avenue
Bridgehampton, New York

Dia Chelsea
537 West 22nd Street
New York, New York

Dia Sites

Joseph Beuys
7000 Eichen (*7000 Oaks*),
inaugurated in 1982 and ongoing
West 22nd Street between and
including 10th and 11th Avenues
New York, New York

Walter De Maria
The Broken Kilometer, 1979
393 West Broadway
New York, New York

Walter De Maria
The Lightning Field, 1977
Western New Mexico

Walter De Maria
The New York Earth Room, 1977
141 Wooster Street
New York, New York

Walter De Maria
The Vertical Earth Kilometer, 1977
Friedrichsplatz Park
Kassel, Germany

Nancy Holt
Sun Tunnels, 1973–76
Great Basin Desert, Utah

Max Neuhaus
Times Square, 1977
Triangular pedestrian plaza at
Broadway and 7th Avenue south
of 46th Street
New York, New York

Robert Smithson
Spiral Jetty, 1970
Great Salt Lake, Utah

Robert Smithson
Spiral Jetty
Great Salt Lake, Utah

Nancy Holt
Sun Tunnels
Great Basin Desert, Utah

Dia Beacon
New York

Dia Bridgehampton
New York

New York City
see inset

Walter De Maria
The Lightning Field
Western New Mexico